PAINTINGS, DRAWINGS AND PRINTS

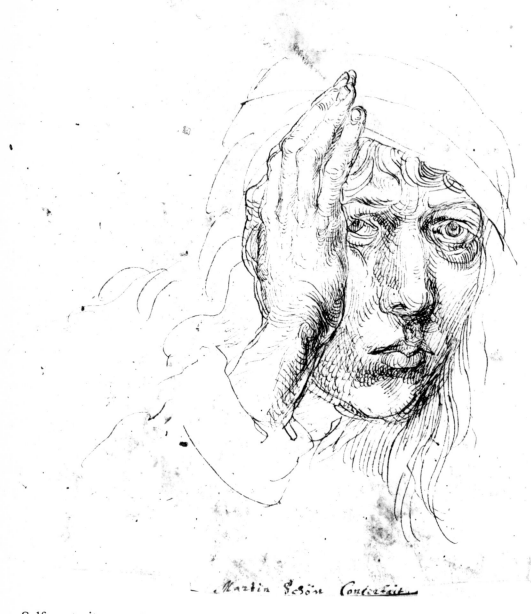

1. Self-portrait. 1492–3.
 Pen drawing. 20.2 × 20.4 cm. Erlangen, University Library.

Albrecht Dürer

PAINTINGS, DRAWINGS AND PRINTS

Selected and Introduced by
Nigel Lambourne

The Folio Society
London 1969

PRINTED IN GREAT BRITAIN
Printed by Westerham Press Ltd, Westerham
Set in 'Monophoto' Plantin
Bound by Nevett, Key & Whiting Ltd, London

Introduction

During the latter years of the fifteenth century, Nuremberg, with its free community and prosperous trades was commonly acknowledged to be one of the most pleasant Nordic cities in which to live and work. Here, some of the miasma of medieval mysticism and dogma was soon to be shaken under the impact of the Reformation. Geographically, the City had developed as something of a reception centre in commerce and the communication of Latin ideas and thought. The wealthier young men frequently went to Bologna, Venice or Florence to complete their education. Craft apprentices often left home for as long as three years abroad before returning to practise in their home town. The clergy were strictly controlled by civic legislation and Mass had begun to be celebrated in German instead of Latin. By the early 1500's the City was becoming noted for its artists, artisans, men of independent thought and, of course, for the rumble of political upheaval.

Albrecht Dürer was born there on 21 May 1471. His father was a goldsmith; his mother, a goldsmith's daughter. He was the third of their children to be born in the tiny rented apartment at the back of what is, today, 20 Winklerstrasse overlooking the main market place.

Shortly after Dürer's fourth birthday, his father moved the family into the first house of their own on the Burgstrasse, then a salubrious quarter. Possibly this is an indication of the goldsmith's increasing prosperity.

Six years later in 1481, the young Albrecht began two years study at the nearby grammar school and after this short spell of general education, he joined his father as an apprentice in the family workshop. There he remained for some three years. In December 1486 he entered the studio workshop of Michael Wohlgemut, a painter of great repute throughout Franconia and a powerful influence in book design and illustration. Dürer remained with Wohlgemut for over three years and was there introduced to the craft of colour grinding, the preparation of surfaces for various pigments as well as the basic technique of the burin.

From a little after Easter 1490 until 1491, our knowledge of Dürer's movements is partially obscured by the dissentious accounts of his biographers of later centuries as well as of the pundits of art history in our time. However, the 'Wanderjahre', a traditional tour abroad for apprentices on completion of their term, gave Dürer his first glimpse of a broader world. And, late in 1491, he arrived in Basle with some excellent references from his godfather and soon found a full time position with the house of Amerbach and Kessler, publishers and printers of some importance. Here, he produced a wide range of work—initials, marginal decorations to various texts as well as textual illustra-

tions. As recent research has shown, he frequently cut blocks from his own designs.

There is also evidence that, towards the end of his stay in Basle, he sent a meticulously painted self portrait back to his father in Nuremberg, in the hope that it might promote a favourable image of a very eligible bachelor. The gesture may have worked well in the first instance, if not as a long term policy. At any rate, he was back in Nuremberg in July 1494, soon after his twenty-third birthday, and made a laconically brief entry in his journal of that year: 'When I returned home, Hans Frey treated with my Father and gave me his daughter, Mistress Agnes by name, and with her he gave me 200 florins and we were wedded a Monday before St Margaret's in July of 1494'.

This 'Mistress Agnes' was a source of inquietude all through Dürer's life. Several contemporary accounts of her are forthright and unflattering. His lifelong friend, Willi Pirckheimer, wrote: 'she watched him day and night and drove him to work hard, for this reason alone . . . that he might earn much money and leave it to her when he died'.

From his twenties until the last year of his life, Dürer maintained a meticulous series of day books of expenses, as well as diaries and treatises on art and human proportion. The British Museum alone possesses five volumes of manuscript, each containing more than 700 leaves with hundreds of marginal drawings.

Dürer first visited Italy late in 1494. The glittering light of the Venetian townscape left a lifelong impression, and later encounters with Mantegna and Bellini influenced both his prints and paintings for many years.

By 1497 he was installed in a large workshop of his own in Nuremberg, but he had begun to find the city oppressive after the revelation of Venice. He had few friends and wrote that he needed the company of travelled people with whom he could exchange theories and ideas. In this year the monogram AD was firmly adopted and his first important patron, Frederick of Saxony, sat for a portrait.

It was now the eve of the Reformation. The old empire order was breaking up. There was an outbreak of miraculous signs and apparitions, shortly to be followed by a physical outbreak of bubonic pestilence across Northern Europe. Dürer wrote that he 'was inwardly filled with awful images'. Yet, success had come relatively early, and several wealthy citizens, encouraged by the Saxon Elector's patronage, began to buy prints and paintings.

During 1500 Dürer's reputation reached Italy where copies of his engravings were being circulated along with anonymous third-rate imitations, all bearing the AD monogram. This may well have been one of the

more obvious reasons for his second visit to Italy in 1505. But certainly a powerful incentive for making the arduous trip was the inexorable progress of the plague. This virulent epidemic had crept back with even greater ferocity to the Nuremberg district in that spring and his wealthiest patrons had left the city. At Christmas of the previous year, only some 14,000 people of the 27,000 population remained alive.

Dürer was still 'inwardly filled' with foreboding and depressed by the recent death of his father. However, he set out on a purposeful but leisurely journey via Augsburg and across the Brenner loaded with baggage, bales of prints and a prospectus of prices for the clients he hoped to meet. Once installed in Venice, he began work on a mural panel for the re-built German Settlement House and, with other commissions, soon made enough money to pay off a loan from his wealthy friend Pirckheimer. He was away from Nuremberg almost two years and shortly before the return journey, wrote: 'how I shall freeze after this sun . . . and too, here I am a gentleman, at home but a parasite'.

Several apprentices were now in the workshop: Hans Baldung Grien, Sebald Beham, and the artist's brother, Hanns. Their assistance was invaluable at this time and they played a large part in the completion of two life-size portraits of the Emperors Charlemagne and Sigismund for the Grand Council Chamber of the City, timed to coincide with the visit of the powerful and despotic Maximilian in 1512. Dürer, Altdorfer and Burgkmair were three of the important artists ordered by the Emperor to devise a Triumphal Car and Arch. But all that finally emerged from the pompous project was a procession of rich allegorical images sprawled across a print nearly eleven feet in length.

Dürer's association with the Emperor, however, was professionally rewarding. Deviously and doggedly, he finally succeeded in obtaining Maximilian's signature for an annual pension of 100 gulden, and from 1515 this life annuity was paid from municipal taxes.

A year previously his mother's painful end had appalled him and he described it with a dramatic force, revealing much of the man and his time. 'She feared Death much and died hard and I marked that she saw something dreadful for she asked for holy water, though for a long time she had not spoken; afterwards her eyes closed. I saw also how Death smote her two great strokes to the heart and how she closed her mouth and departed with pain.' She had borne eighteen children and had lived long enough to bury fifteen of them. Shortly before she died, Dürer made a powerful drawing of her; affectionate yet redolent of his deep rooted awe of death and arcane powers.

At this time the influence of Martin Luther was spreading aggressively, bringing with it popular unrest, and Dürer made several fruitless attempts to meet him. But among the many prints the artist sent to the great rebel, the most significant was the famous engraving symbolising Lutheran courage, *The Knight, Death and devil.*

At the end of January 1519, Maximilian died and Dürer became worried that the life annuity might be terminated. It was in fact suspended. He was now frequently ill with splenetic depressions, but there seemed no alternative to an audience with the new young Emperor Charles V. The long journey to Aachen became a full scale expedition. Mistress Agnes insisted on vast stores of domestic goods and supplies as well as a maid, whilst he packed his entire stock of prints, painting materials and large bundles of drawing-paper. On 4 October 1520, he finally held the coveted document confirming the life annuity and they began a meandrous return itinerary, visiting Brussels, Ghent, Antwerp and Bruges; he also found time to make two portraits of the great Erasmus.

It was his last and, in many ways, his most productive voyage, but it also aggravated his failing health. In late December he made a detour alone to Zeeland, where a great whale had been stranded. After a nightmare sea journey, he arrived only to find the monster had been washed away. Soon afterwards, he noted the first symptoms of 'a wondrous sickness the like of which I have heard no man relate'. Attacks of violent fever and fainting recurred at frequent intervals and, through the last six painful years of his life, he grew steadily more emaciated.

Less than a year after his return from the Netherlands he began a general and exhaustive revision of his manuscripts. Many of his letters and comments suggest that he was beginning to accept the approach of death. He undertook several portrait commissions and began to write a family chronicle. During 1526 his health temporarily improved and he completed a monumental work for the City Council, *The Four Apostles.* But early in the following year the sickness returned more inexorably than ever.

War was now imminent between France and Germany. Vast crowds of militant peasants were pillaging farms and murdering villagers. The Turks had arrived in Western Hungary and the fortification of cities became a major concern. For many years Dürer had been interested in this complex engineering problem and, less than a year before his death, a very complete theoretical treatise, his *Unterricht zur Befestigung der Städte,* was published and widely circulated.

But now, by February 1528, there was little time left, and he was forced to rest for long periods away from his workroom. He slept fitfully and suffered visions of nightmare and apocalyptic dimensions. One of them exists in the form of a water colour drawing; an enormous unleashing of natural forces which he also described in a notebook—'a deluge of many great waters struck the earth from a great height with gathering swiftness and wind and roaring so that it was long before I came to myself again'.

In the last few weeks of his life he continued to correct proofs of his prodigious *Treatise on Proportion,* a work published only a few weeks after his death. It appeared in five languages over the next 120 years, and an English edition was published in 1660.

In the early hours of 6 April 1528, he died. Pirckheimer read a florid Latin oration over the open grave in Nuremberg's St Johannis Cemetery, and, later, erected a plaque bearing the renowned monogram, AD.

His wife Agnes inherited over 1,000 gulden, providing her with complete independence and a relatively patrician status.

Contents

Paintings and drawings

PAINTINGS

Perhaps there is more dissension surrounding Dürer's merits as a painter than in any other aspect of his work. Much of the criticism is loose and ill-informed, but few professional painters are very willing to concede more than admiration for the sheer craftsmanship.

It is in direct relation to his Italian colleagues that this painstaking solid German is unflatteringly revealed as a workman rather than as a painter; as one who colours his drawing rather than as a natural manipulator of pigment in the terms of Bellini, Carpaccio, Giorgione or Titian.

Dürer wrote much on the craft of painting and vision in particular. At one point he remarks: 'what beauty is I do not know, but it must depend upon many things. The artist must enquire widely so that he will have a mind well stored'. Regarding the image of the figure he says, 'it must be acquired and learnt well before'. At another time he speaks of 'the secret images of the heart', which contrasts vividly with his scrupulous observation and fidelity when in the presence of a sitter or a humble domestic utensil. And when Dürer has had his perceptive dissertation on painting and man, and one has looked at his conclusions, it is not unreasonable to assume that painting is not by nature part of the Gothic world. It is in the arts of print making and linear imagery that German artists emerge as powerful creative personalities.

In the following selection of work, some emphasis has been given to the smaller pictures; landscapes are of particular interest here since they are perhaps among the less known of his earlier paintings. Also, they have a lightness and freedom due in some part to Dürer's obvious sympathy with gouache and water colour as a means of direct expression. Yet they are never sketchy or unresolved. It is in the larger scale oil paintings that a representative selection becomes more difficult, partly because of the frequently harsh and at times commonplace colour threnodies, and also because of the overloaded sentiment in religious contexts.

In the portrait of his father (7), the drawing is firm, the sense of character penetrating and there is no sense of strain in the use of colour. His self-portrait of 1498 (9) is similarly controlled but a Gothic rigidity is only just under the surface. This rigidity is apparent throughout the later and larger commissions he undertook and is reflected not only in the design of the densely packed panels but also in the attempts to reconcile most improbable colour and texture.

In the portraits generally, there are two significant and irreconcilable influences; the intense realism of the later Flemish painters and the severity of Italians such as Crivelli, Signorelli and, of course, Mantegna. It was, however, the Flemish idiom that he appears to have most admired to the end of his life.

DRAWINGS

In view of Dürer's tremendous output of drawings in many media, it is depressing to realise that relatively few of them remain as authentic examples of his hand.

However, in this somewhat brief survey of his original drawings, which covers nearly forty years, his range of graphic expression is often surprising in its variety of media and, equally important, in terms of technical freedom. The brutally grotesque caricature quality of 'Memento Mei' and the renowned pair of hands (14) offer dramatic contrasts in both thought and purpose. Again, the elaborate study for the engraving 'The Prodigal Son' (8), is relentlessly studious as if the engraver needed a veritable manual of graphic instructions before translating the imagery into a cut line.

Unlike some of his Italian contemporaries, Dürer seldom concerned himself with the swirl and lightness of arabesque qualities. It was as unsympathetic to his temperament as the idiom of 'Melencolia' would have been to Bellini or any of the Venetians of that time. Yet, in the 'Head of an old Man' (17), an almost unconscious tribute to the great Italian draughtsmen may be seen in the treatment of the hair and beard; more than a hint of Mantegna, Leonardo or Lippi is there. This drawing combines many of Dürer's obsessions with natural appearances and yet triumphs over the mundane acceptance of surface detail. An emotional reaction seems to take over in the rolling, sagging forms of the face. It is one of the rare drawings from his hand in which intellect and passion (almost) are equally realised.

As a delineator of things seen, of causes and effects, Dürer must always remain one of the greatest draughtsmen, but at the same time, for all his clear and bitter analyses, he inherited a world of conventional themes and often the recipes for their expression. His visits to Italy exposed him to fresh ideals and no doubt tempered some of his Germanic pertinacity. His Venetian colleague, Jacopo de' Barbari, was a potentially good influence in this respect. Not least of Dürer's obsessions was the lifelong quest for a canon of human proportion; and although he constantly sat drawing the grotesque parade of flesh in the Nuremberg public baths, it is ironically true that the pot-bellied hags and scrawny men provided him with an all too natural and recurrent canon which he could never accept. Sensuousness in drawing the nude form also eluded him; his obsession with what should or could be mathematically realised as a recipe always stood in the way. He once wrote home from Italy, that he would rather be shown a true system of proportion than 'behold a new kingdom'. The neo-classical affectations of many Renaissance artists are to be seen in some of his drawings after 1500, and he attempted to reconcile these traits with his personal view of the world. It is seldom convincing.

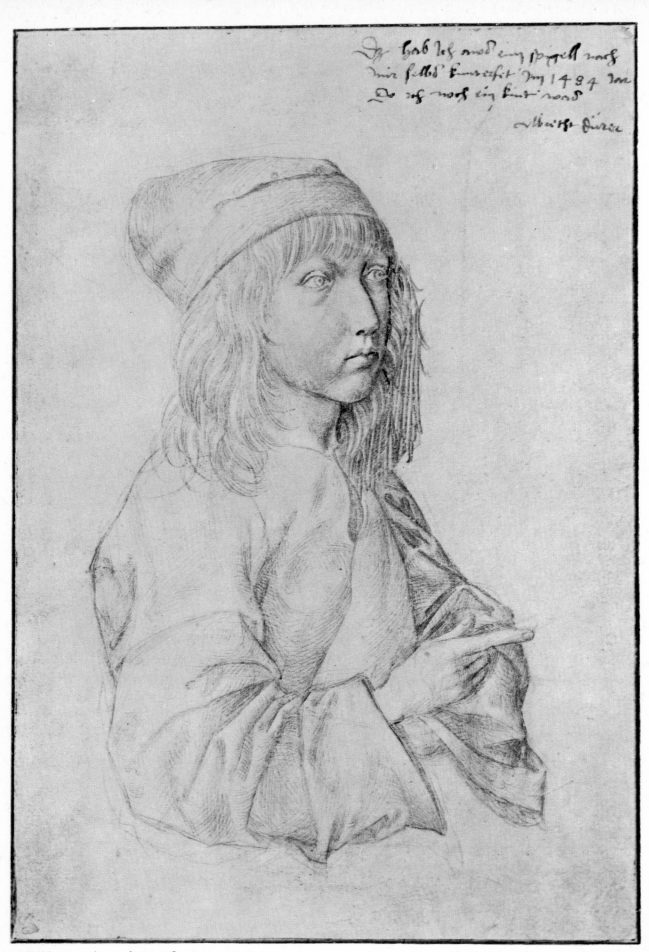

2. Self-portrait aged 13. 1484.
 Silverpoint. 27.2 × 19.6 cm. Vienna, Albertina.

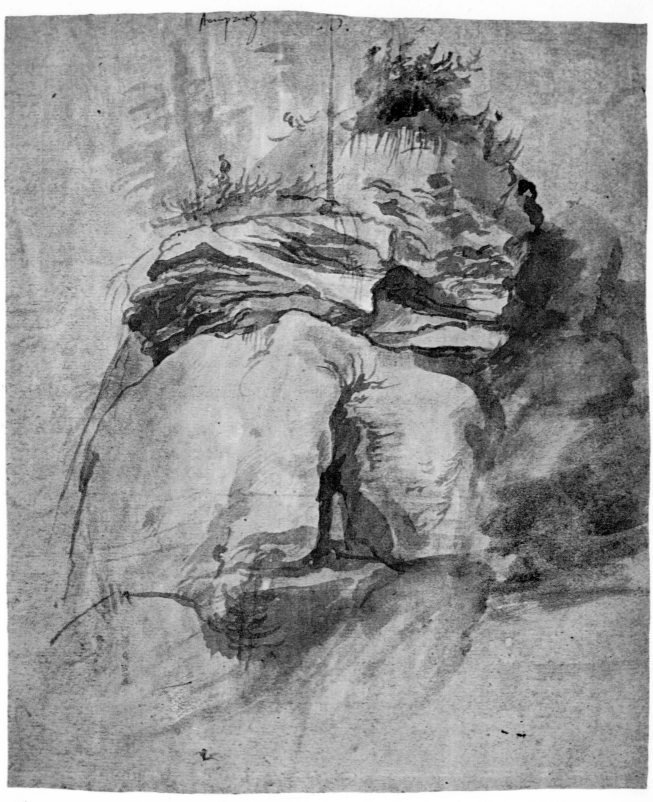

3. A quarry. 1495.
 Watercolour. 23.2 × 19.7 cm. Milan, Ambrosiana.

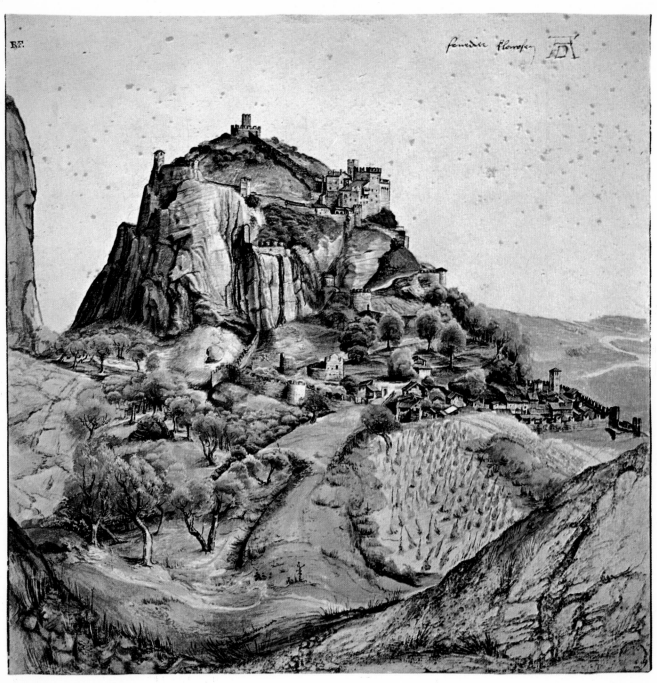

4. View of Arco. 1495.
 Watercolour and gouache. 22 × 22 cm. Paris, Louvre.

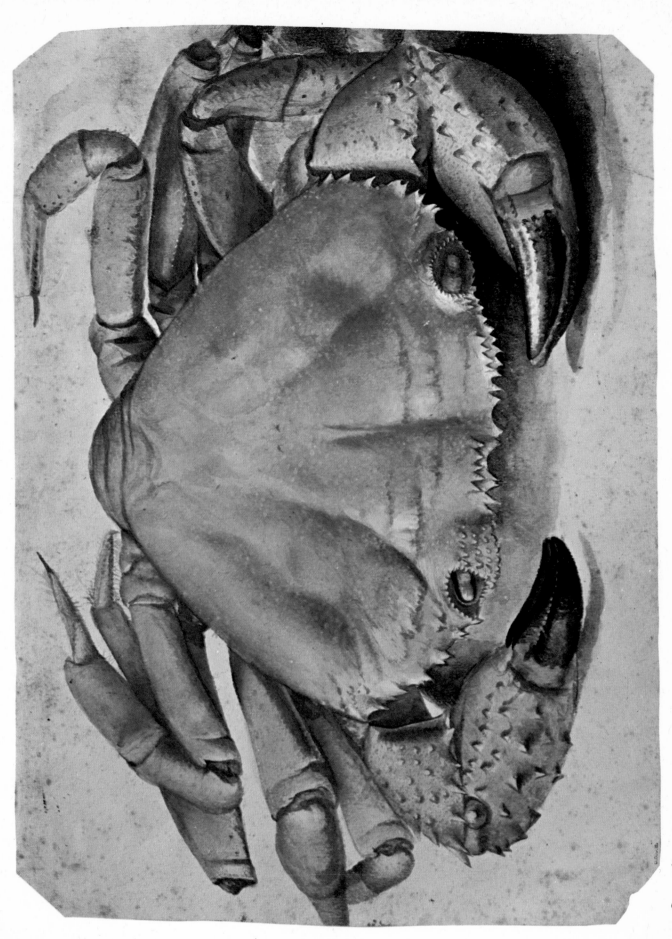

5. Sea crab. c. 1495.
Watercolour and gouache. 26.1 × 35.6 cm. Rotterdam, Van Beuningen.

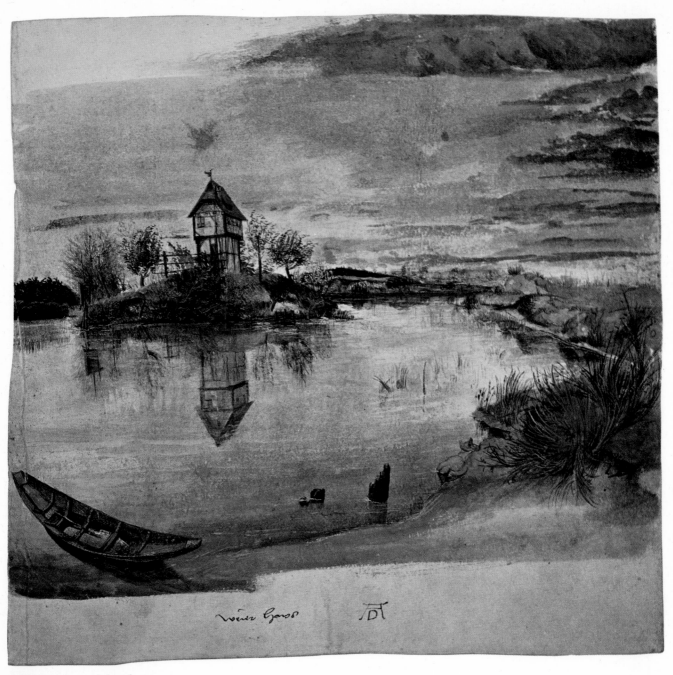

6. House on an island. 1495–7.
 Watercolour and gouache. 21.4 × 22 cm. London, British Museum.

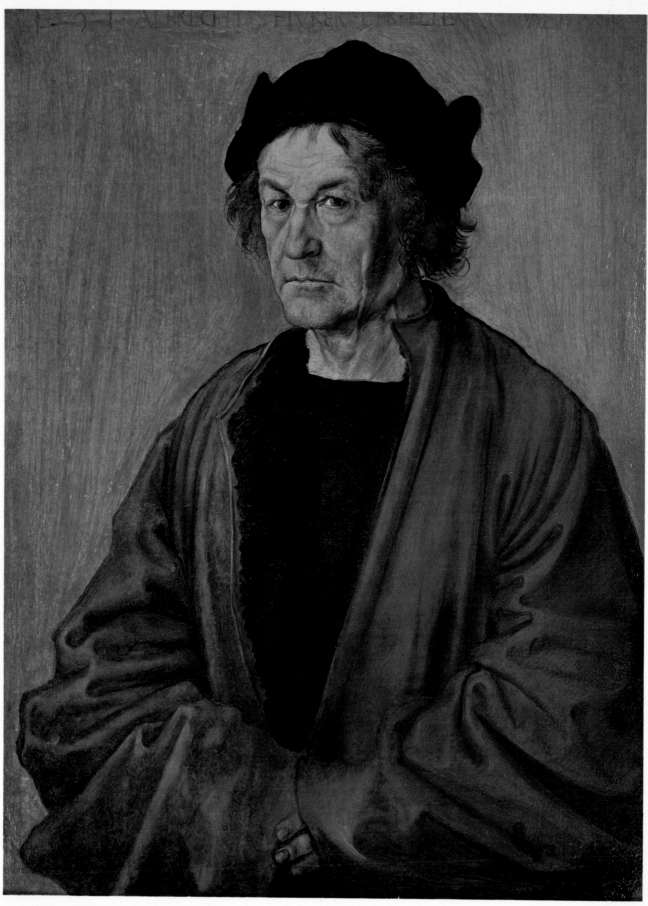

7. Portrait of the artist's father. 1497.
 Oil. 60 × 40.7 cm. London, National Gallery.

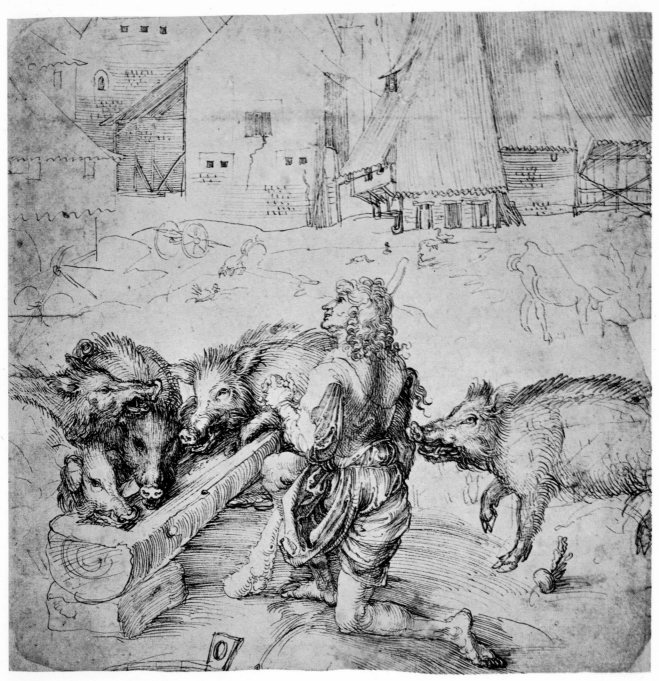

8. The prodigal son: study for an engraving. 1497–8.
Pen. 19.1 × 24.8 cm. London, British Museum.

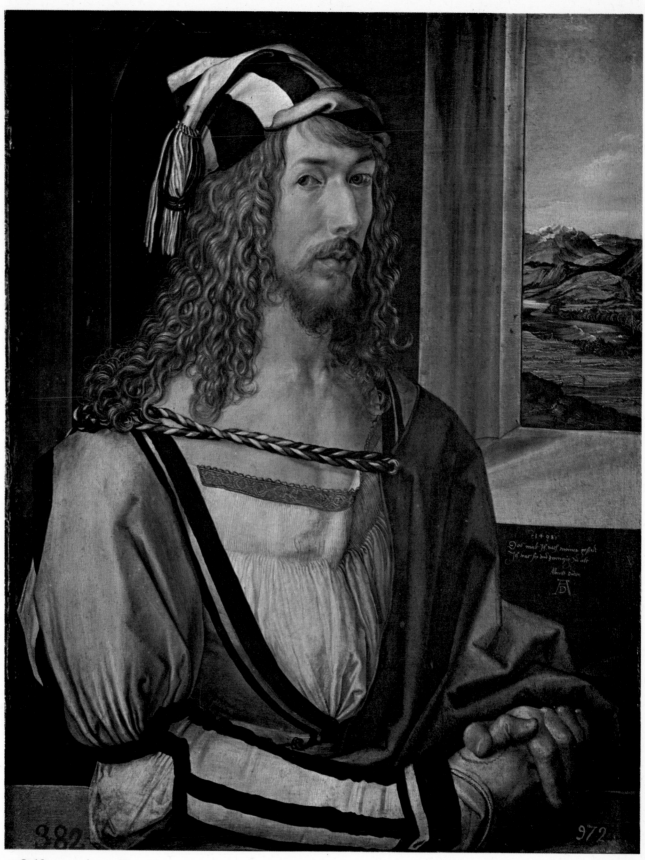

9. Self-portrait. 1498.
 Oil. 52.2 × 41.1 cm. Madrid, Prado.

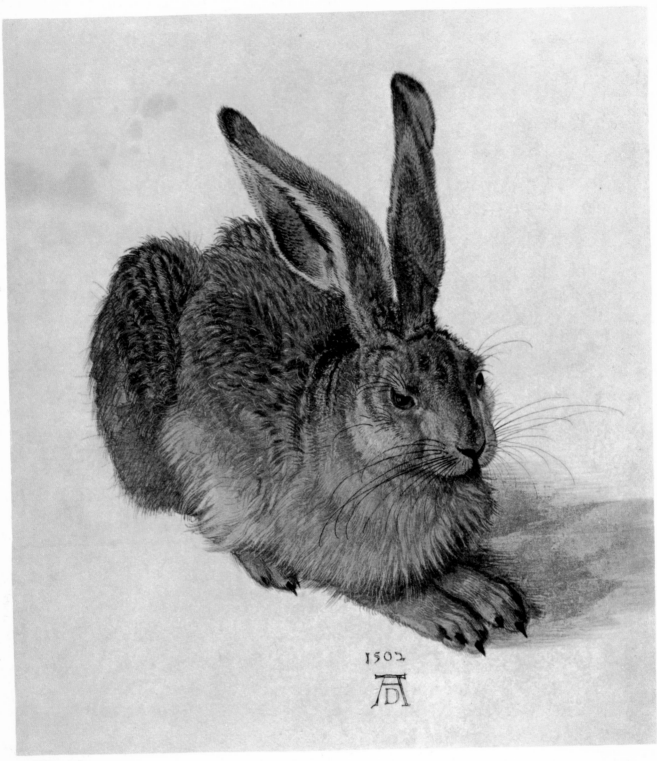

10. Young hare. 1502.
 Watercolour. 25.1 × 22.6 cm. Vienna, Albertina.

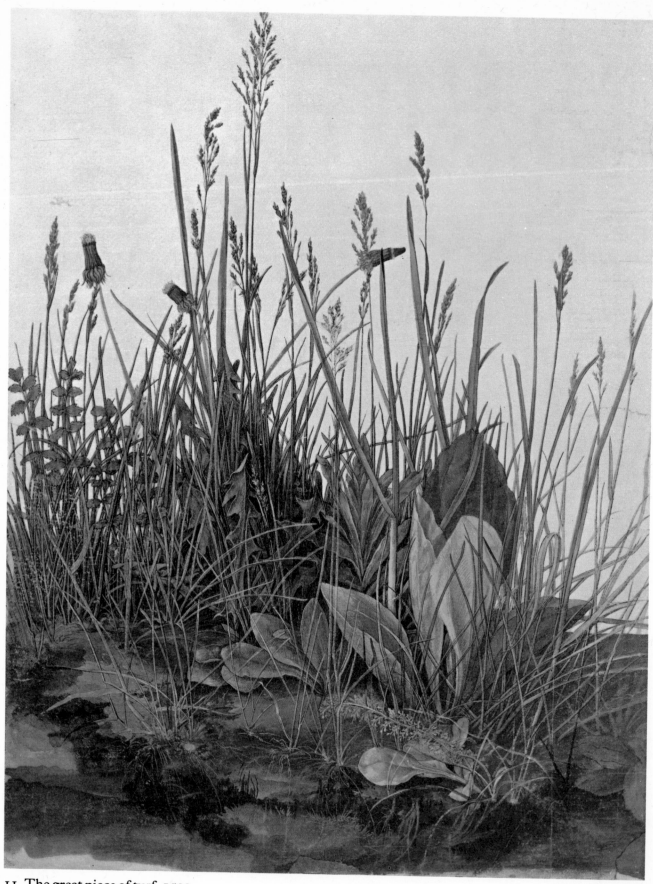

11. The great piece of turf. 1503.
 Watercolour and gouache. 41.1 × 31.5 cm. Vienna, Albertina.

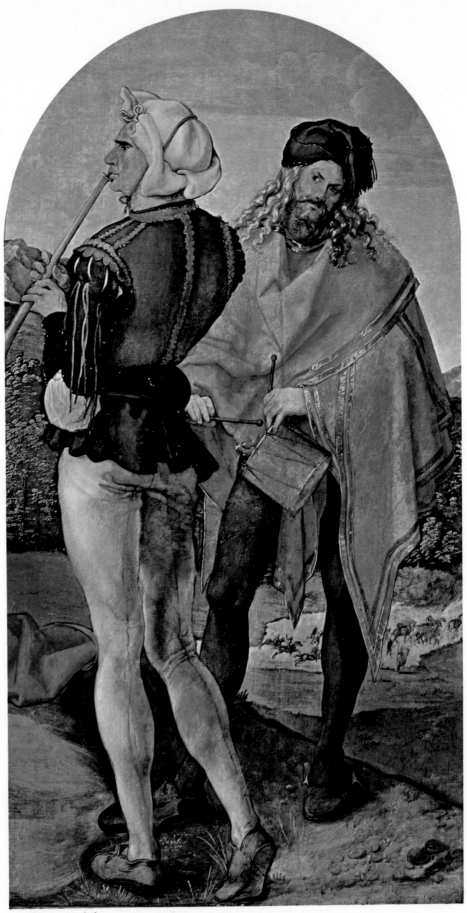

12. Piper and drummer. 1504.
Oil. 102.4 × 60 cm. Cologne, Wallraf-Richartz Museum.

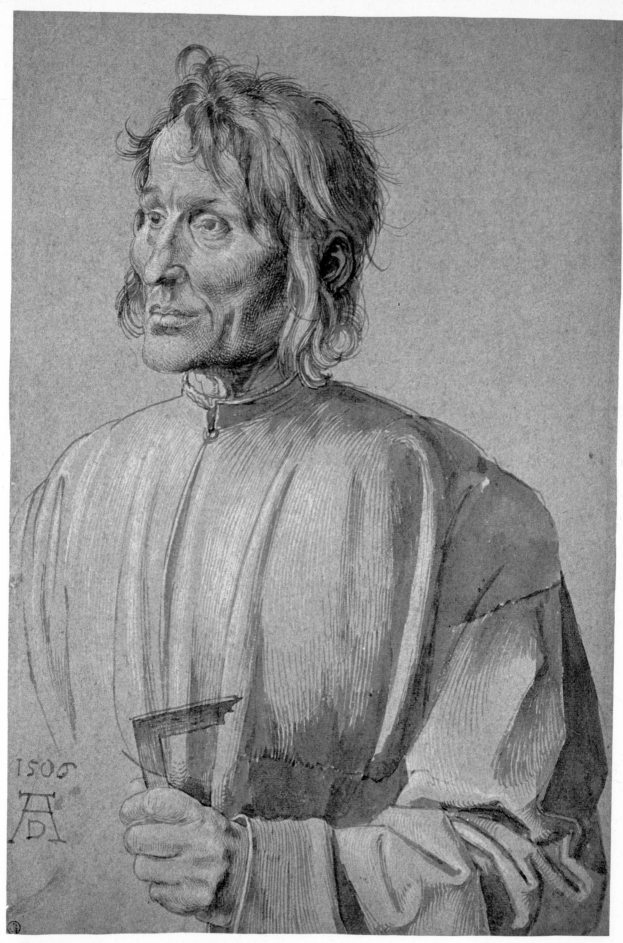

13. Portrait of Hieronymous of Augsburg. 1506.
 Pen and brush. 39.9 × 26.3 cm. Berlin, Kupferstich-Kabinett.

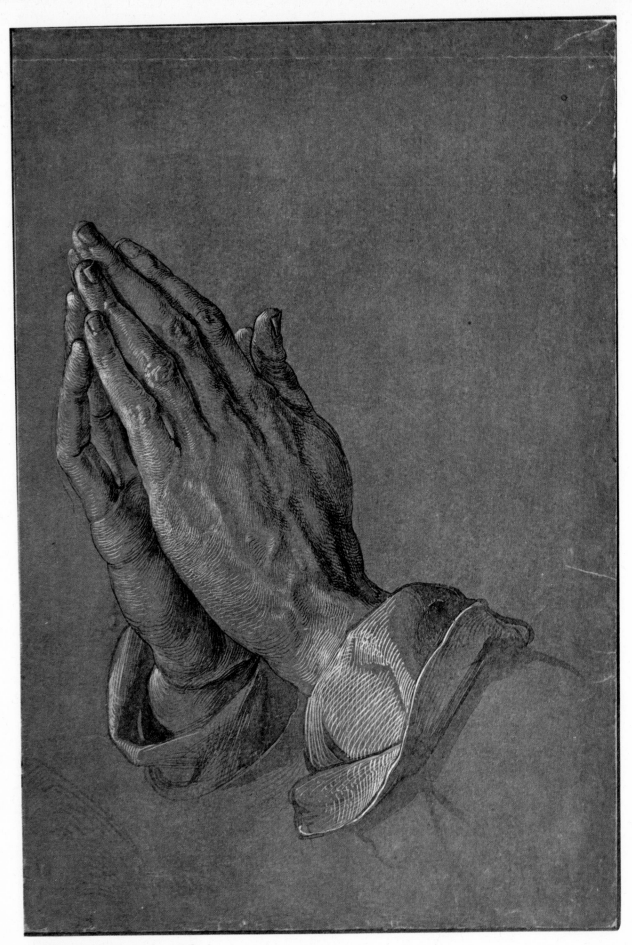

14. Hands of an apostle. 1508.
 Pen and brush. 29.1 × 19.7 cm. Vienna, Albertina.

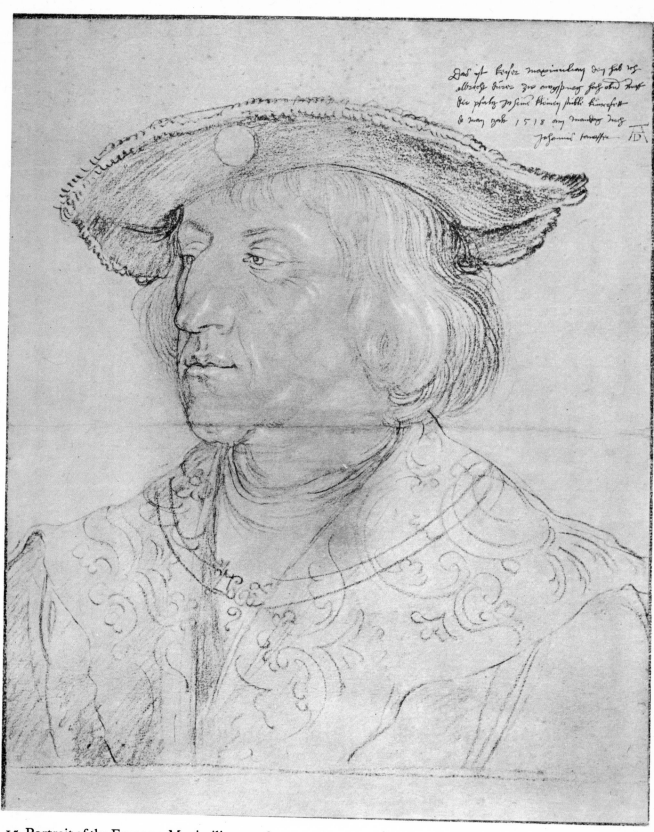

15. Portrait of the Emperor Maximilian. 1518.
 Watercolour. 38 × 31.8 cm. Vienna, Albertina.

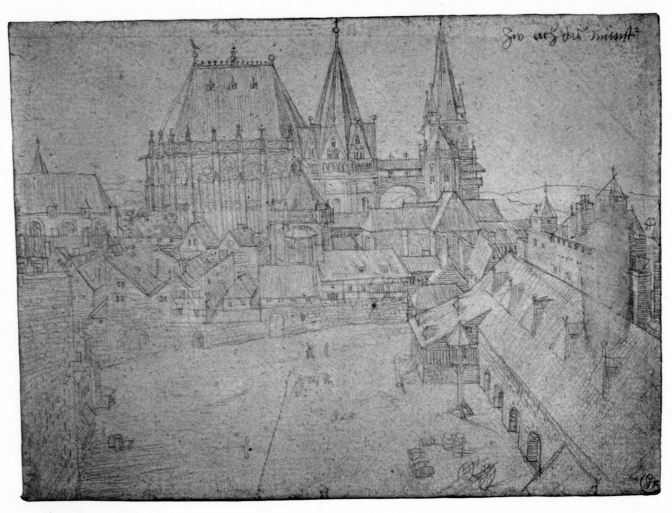

16. Aachen Minster. 1520.
 Silverpoint. 17.8 × 21.1 cm. London, British Museum.

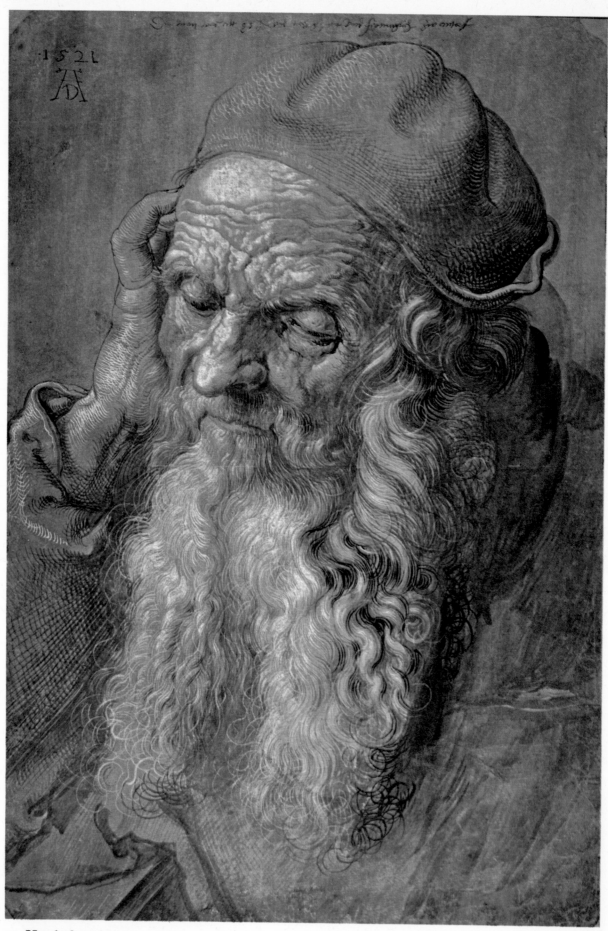

17. Head of an old man. 1521.
 Brush. 48.4 × 32 cm. Vienna, Albertina.

Prints from metal

Germanic technical dexterity was one of the most powerful influences in creative print making during the fifteenth century. It reached a dazzling pinnacle with Dürer. But this wizardry soon degenerated into repetitive displays of factual imagery; great craftsmen produced works with very little to say, but they expended an enormous number of hours saying it superbly well. Pure imagination, coupled with the expressiveness of a line with a life of its own, began to disappear with the anonymous Masters of the 1460's, ending perhaps with the death of Dürer's senior and greater compatriot, Martin Schöngauer.

For example, in Dürer's technical tour de force, 'Melencolia' (38), one may glimpse some of the Nordic passion for precision; the delight in wealth of detail for its own sake, in factual definition rather than suggestion. In exactly these terms, his prints were appreciated by a wide but largely unsophisticated public; the craftsman's dexterity was venerated as an end in itself, and detail could be piled upon detail until illusion or any challenge to the imagination was lost. (Perhaps Ruskin was at his most perceptive when he wrote that 'to engrave well is to ornament a surface well, not to create a realistic impression'.)

But even more important, during the latter part of Dürer's life, engraving was becoming a reproductive process, and thus the seeds of decadence were sown. It soon became a means of disseminating drawings and paintings and continued as such for the next three centuries.

Nevertheless, Dürer must always remain a giant figure, not only in the rhythm of his life and time but also in the history of the medium itself, since no artist of his stature had ever taken to it with such an intensity of exploitation.

Any appraisal of such a master draughtsman must have its roots in personal reactions and is thus probably of ephemeral interest. Therefore, it seems to me important that a balance be attempted between some technical appreciation of the means, and a critical review of the final image.

Although Dürer's conceptions were constantly overwhelmed by his infallible technique, some of his earlier plates dating from the 1490's possess a simplicity and a direct, uncluttered imagery. 'The ill-assorted couple' (19), 'The Turkish family' (25), or even the later plate, 'Peasant couple dancing' (39) are notable for their humanity and are unspoiled by frenzied elaboration. Compare these with such monumental prints as 'Knight, Death and devil' of 1513 (37), or even 'St Eustace' (30) where the obsessive overloading of infinitely calculated cuts and stipples destroys both the concept and the inherent qualities of the medium.

Again in contrast, this ease and fluency in the cutting of the plates is strangely absent in the few etched prints he produced. In one sense they are needle drawn lines *emulating* the precision of the pushed burin. Rather than a freely flowing pen-like delineation, there appears the familiar, faithful portrayal of fact in terms of rigid precision. This quality is evident again in an etching on an iron plate, 'The cannon' (41); only in the middle distance of the broad landscape does he tend to relax the drawing. And certainly, in the largest plate he is known to have etched, 'The abduction of Proserpine' (42), the needle or stylus is controlled entirely in the tension and idiom of the burin. But in the 'St Jerome by the pollard willow' (36), Dürer worked almost entirely in drypoint and the result is something of a compromise between cutting and etching. This plate also has a breadth of treatment and unity frequently missing in the engravings.

At this time there had been few attempts to use etching for purely creative print making, and Dürer may well have been merely curious regarding the chemistry of the technique; but there is little evidence that he was prepared to exploit the medium in depth. After 1518, it seems unlikely that he returned to it, although there are some professors who are prepared to believe otherwise—particularly those pundits who will remain forever dazzled by virtuosity, and consider it synonymous with sensitive perception.

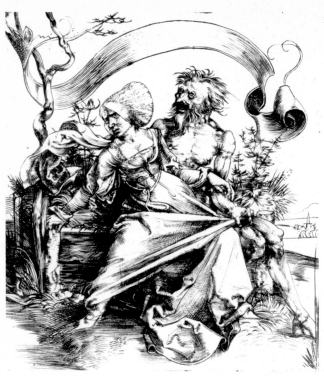

18. The ravisher. 1495.
 Engraving. 11.5 × 10.5 cm. London, British Museum.

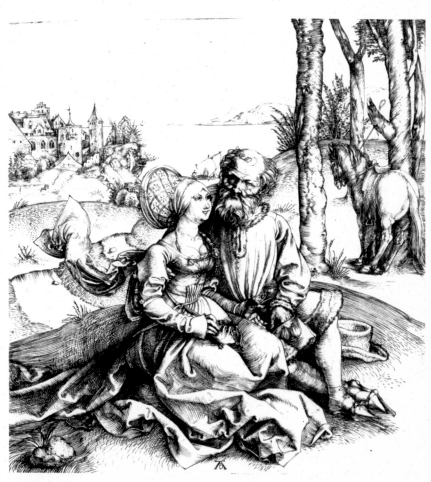

19. The ill-assorted couple. 1495.
 Engraving, 1st state. 15 × 14 cm. London, British Museum.

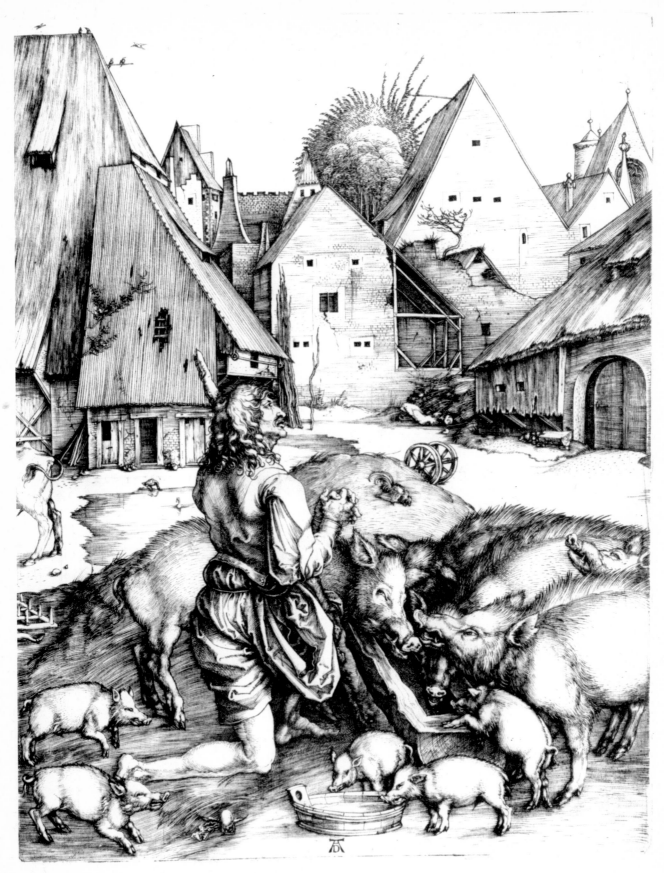

20. The prodigal son. 1496.
 Engraving. 24.5 × 19.2 cm. London, British Museum.

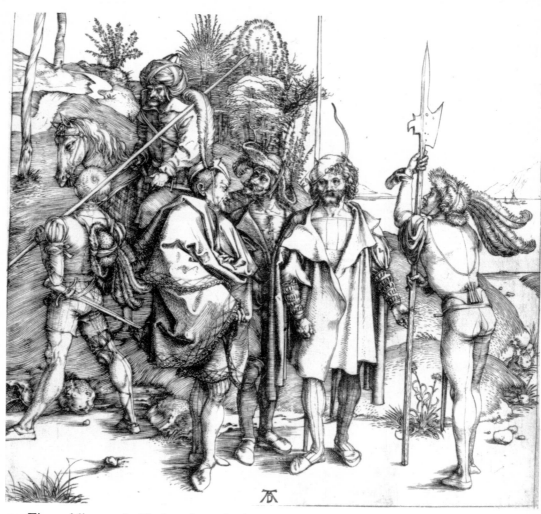

21. Five soldiers and a Turk on horseback. *c.* 1496.
Engraving. 13.4 × 14.5 cm. London, British Museum.

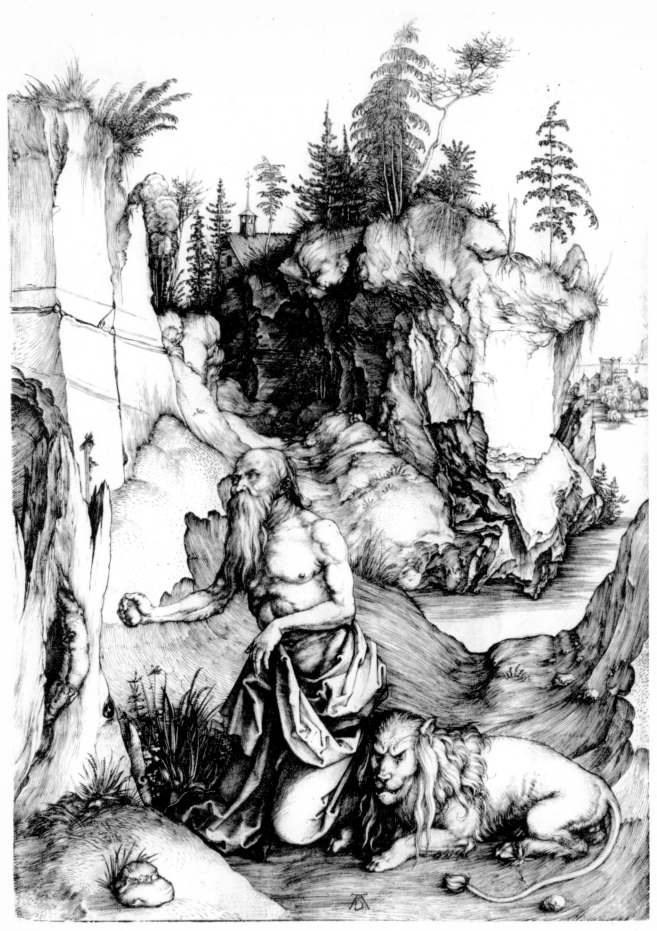

22. St Jerome in penitence. *c.* 1496.
 Engraving. 32 × 22.8 cm. London, British Museum.

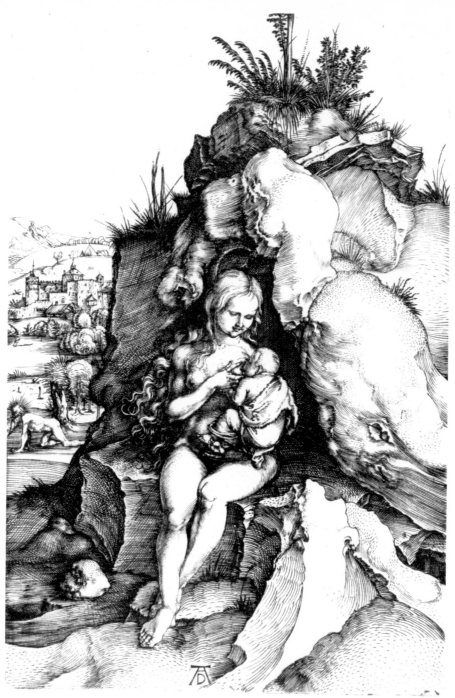

23. The penance of St John Chrysostom. *c.* 1496.
Engraving. 18 × 12 cm. London, British Museum.

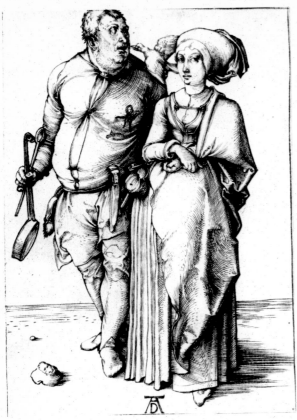

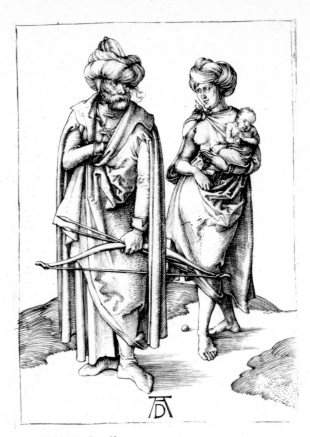

24. The cook and his wife. *c.* 1496.
Engraving. 11 × 8.2 cm. London, B. M.

25. Turkish family. *c.* 1497.
Engraving. 11 × 8 cm. London, B. M.

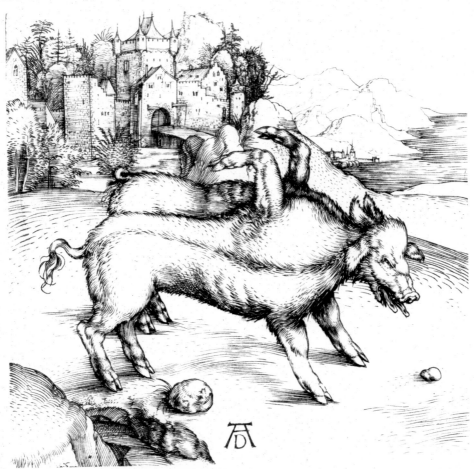

26. The monstrous pig of Landser. *c.* 1496.
Engraving. 12 × 12.8 cm. London, British Museum.

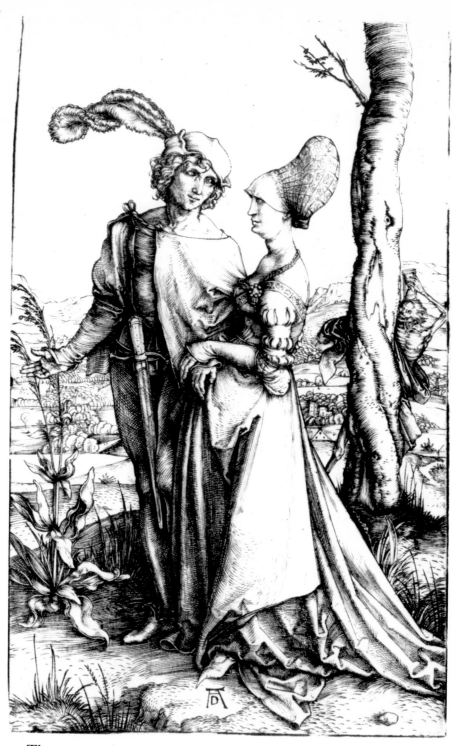

27. The promenade. *c.* 1496.
Engraving, 1st state. 19 × 12 cm. London, British Museum.

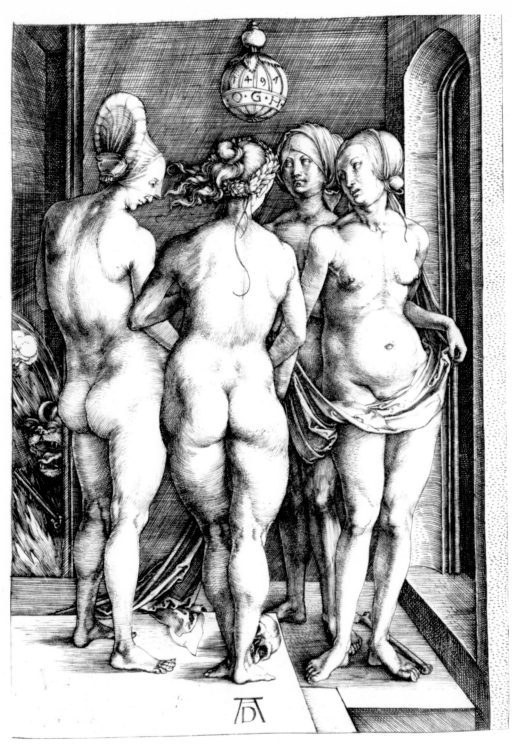

28. Four naked women. 1497.
 Engraving. 19 × 13.5 cm. London, British Museum.

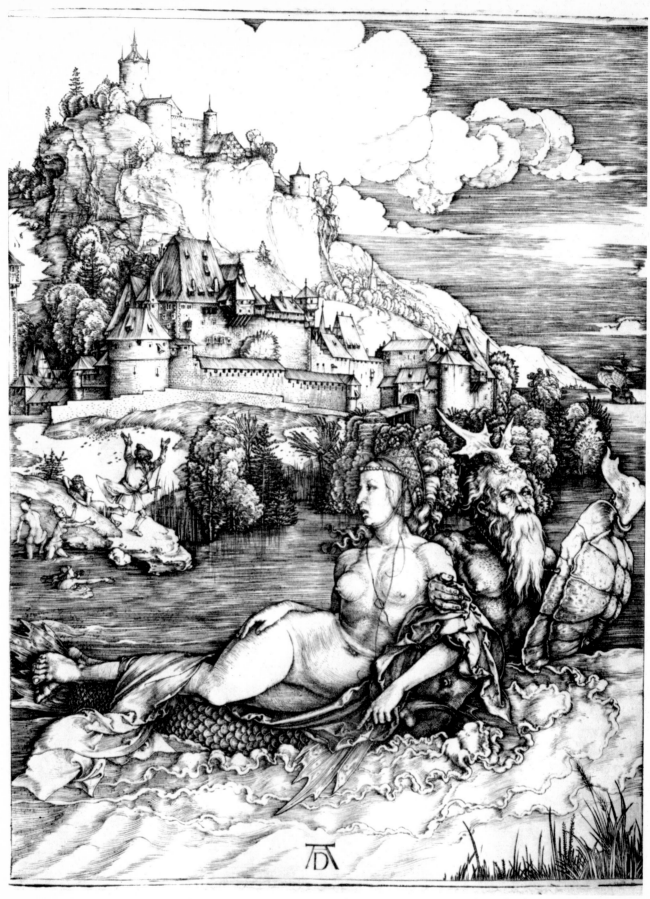

29. The sea monster. 1498.
 Engraving. 24.8 × 18.5 cm. London, British Museum.

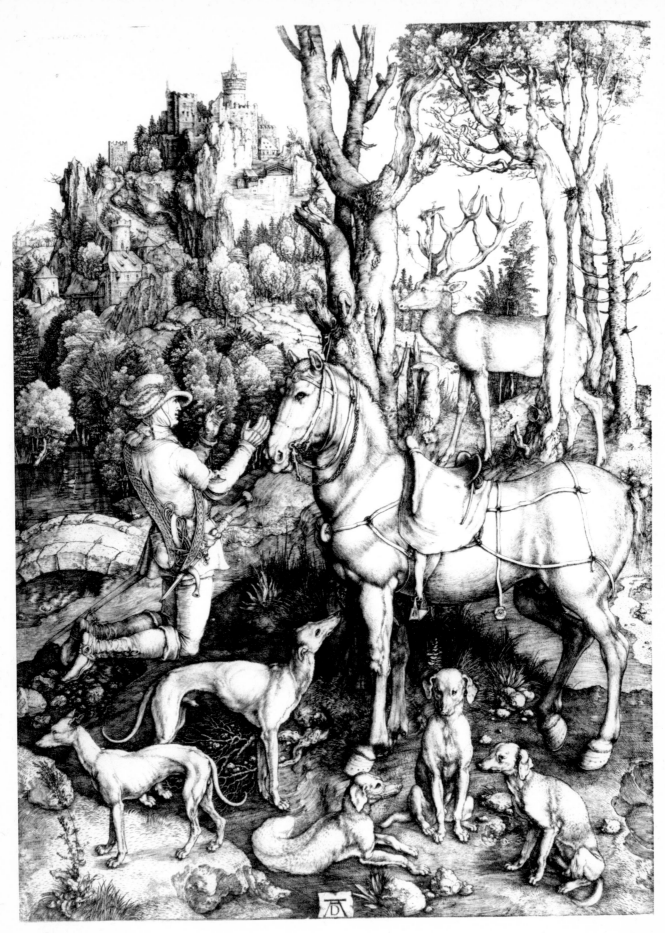

30. St Eustace. *c.* 1501.
 Engraving. 35.7 × 26 cm. London, British Museum.

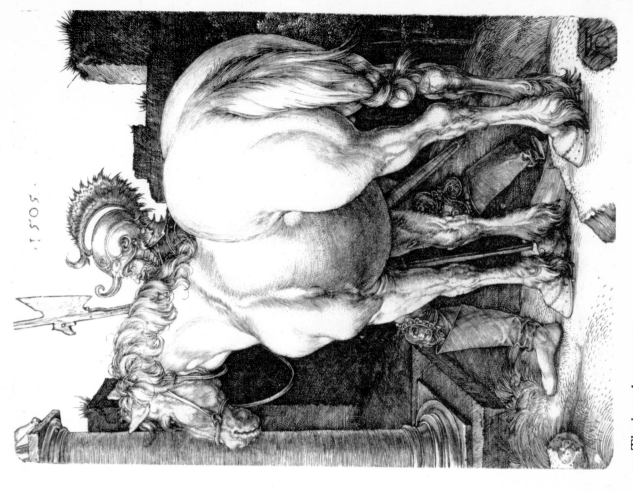

32. The large horse. 1505.
Engraving. 16.5 × 11.5 cm. London, British Museum.

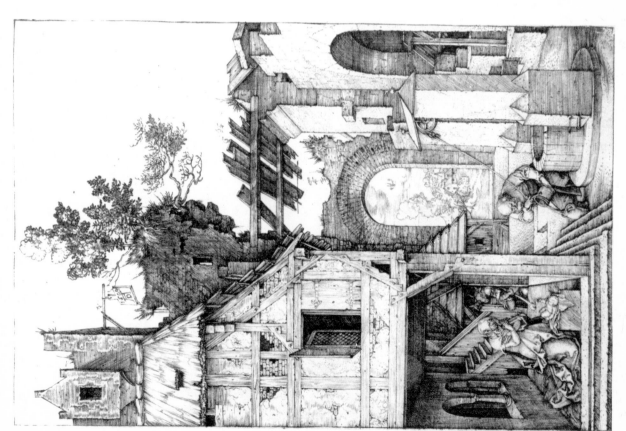

31. Nativity. 1504.
Engraving. 18 × 12 cm. London, British Museum.

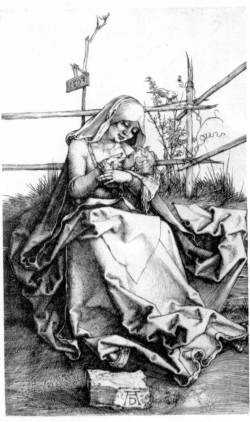

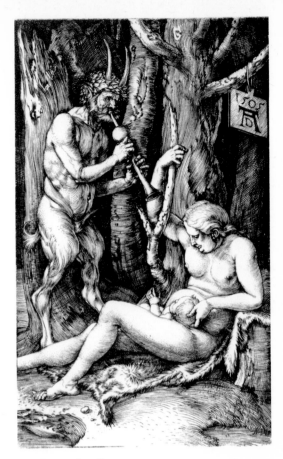

33. Virgin and child on a grassy bank. 1503.
Engraving. 11 × 7 cm. London, B. M.

34. Satyr family. 1505.
Engraving. 11.5 × 7 cm. London, B. M.

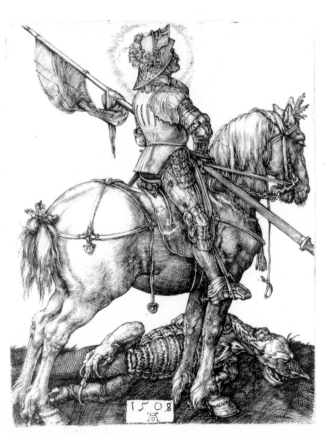

35. St George on horseback. 1505–8.
Engraving. 11 × 8.5 cm. London, British Museum.

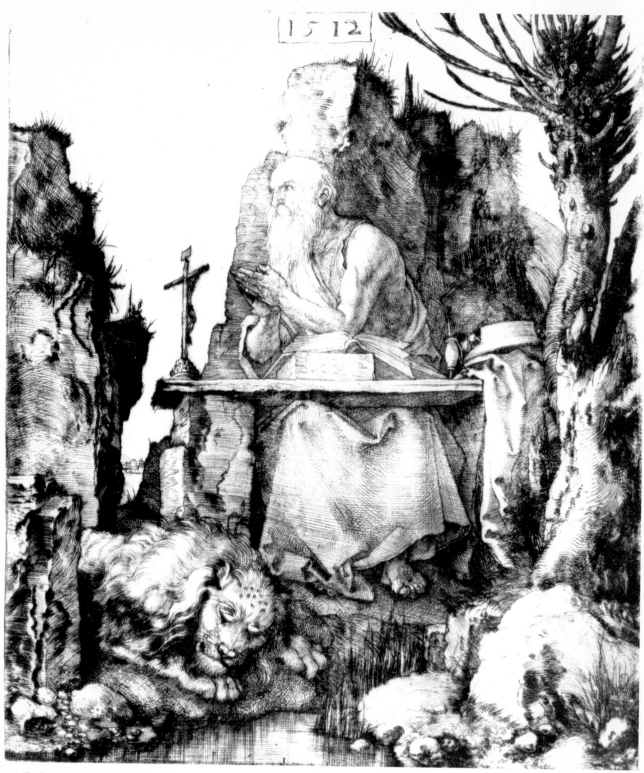

36. St Jerome by the pollard willow. 1512.
 Drypoint. 21 × 18.5 cm. London, British Museum.

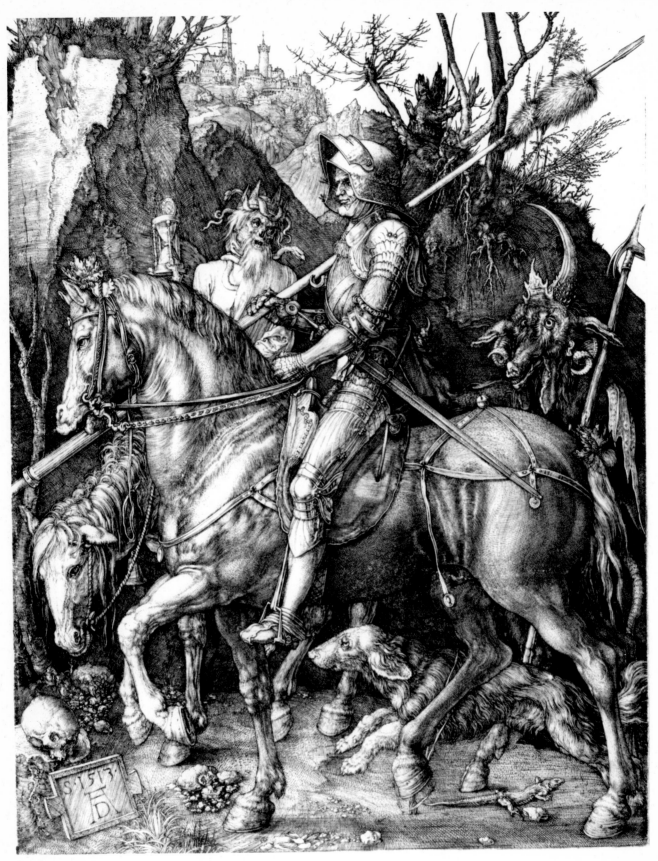

37. Knight, Death and devil. 1513.
 Engraving. 25 × 19.5 cm. London, British Museum.

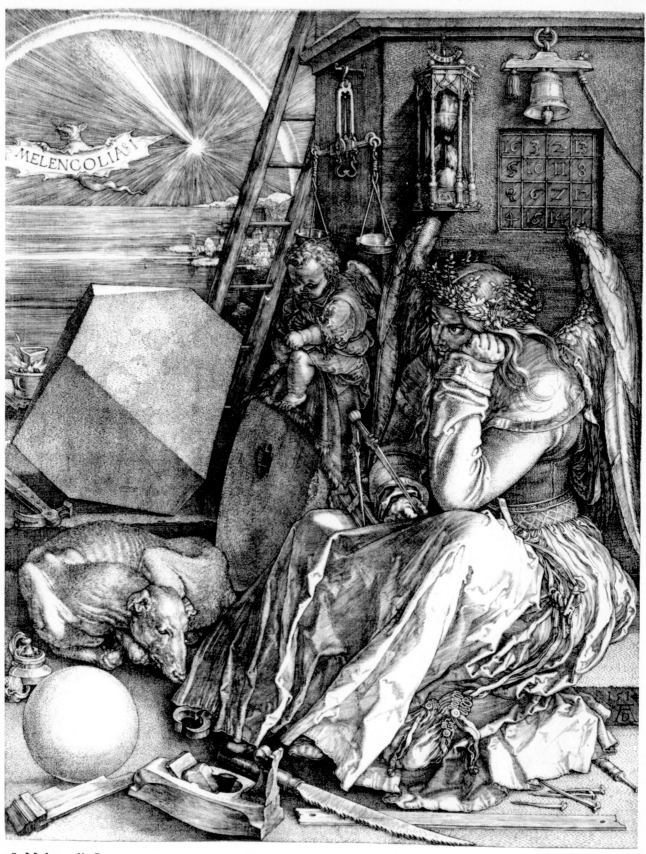

38. Melencolia I. 1514.
Engraving, 2nd state. 24 × 19 cm. London, British Museum.

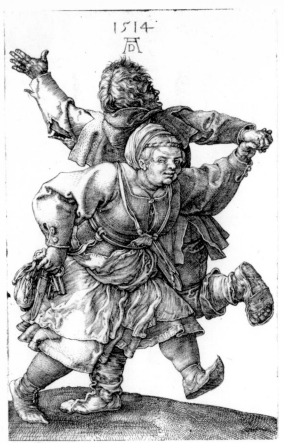

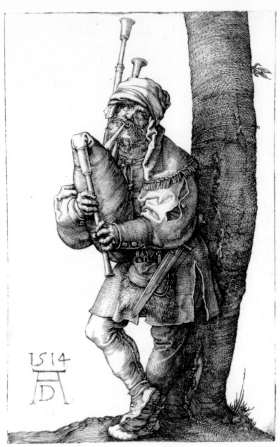

39. Peasant couple dancing. 1514.
Engraving. 11.5 × 7.5 cm. London, B. M.

40. The bagpiper. 1514.
Engraving. 11.5 × 7.5 cm. London, B. M.

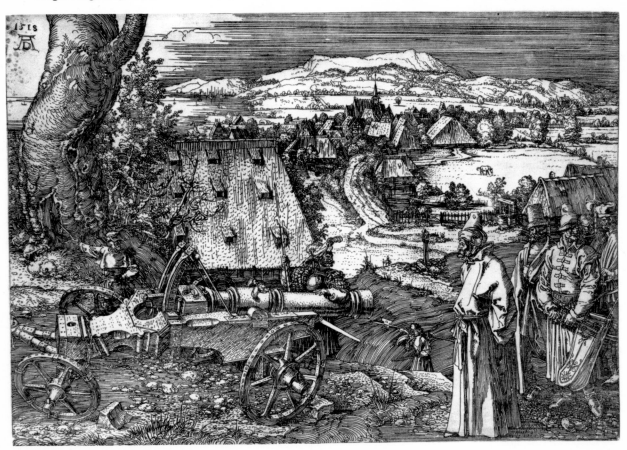

41. Landscape with the cannon. 1518.
Etching. 21.8 × 32.2 cm. London, British Museum.

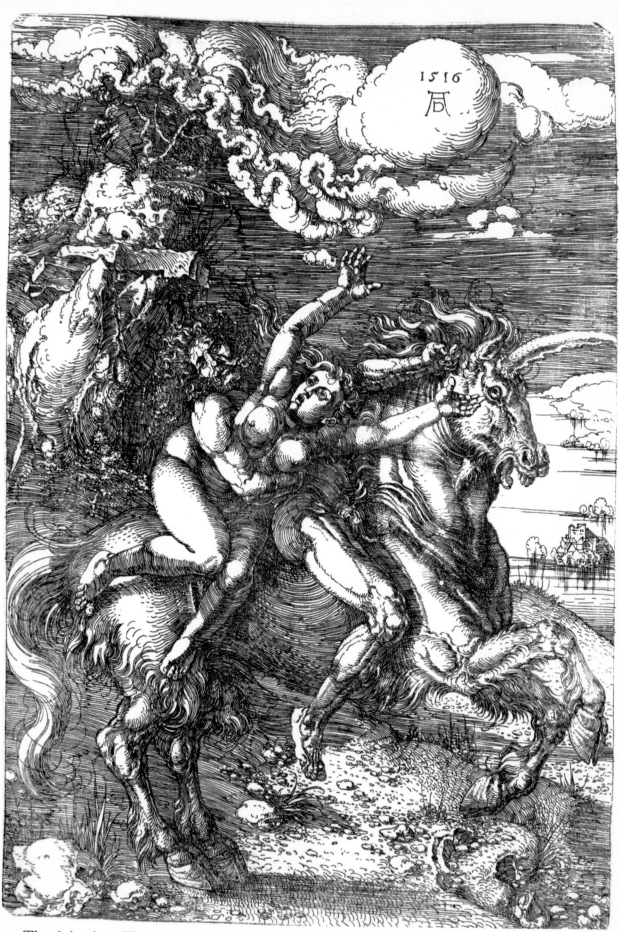

42. The abduction of Proserpine. 1516.
 Etching. 30.5 × 20.5 cm. London, British Museum.

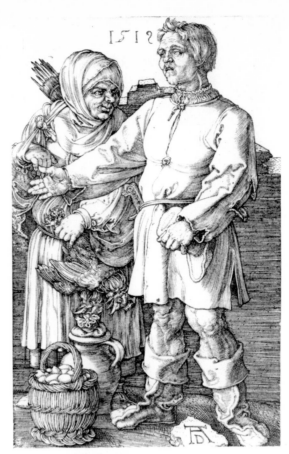

43. Peasant couple at market. 1519.
Engraving. 11.7 × 7.4 cm. London, B. M.

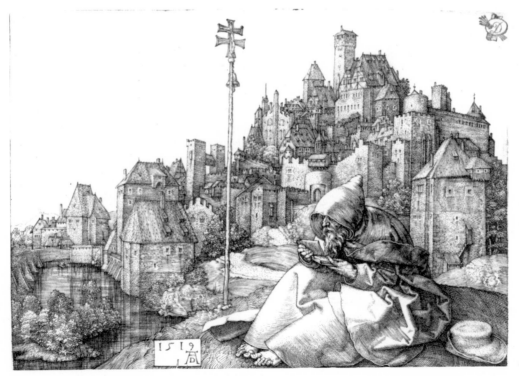

44. St Anthony reading. 1519.
Engraving. 9.5 × 13.5 cm. London, British Museum.

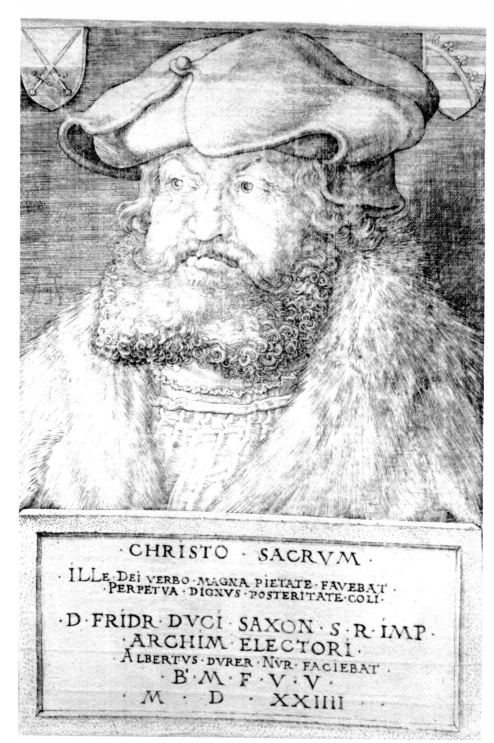

CHRISTO · SACRVM ·

ILLe DEI VERBO · MAGNA PIETATE · FAVEBAT ·
PERPETVA · DIGNVS · POSTERITATE · COLI ·

D · FRIDR · DVCI · SAXON · S · R · IMP ·
ARCHIM · ELECTORI ·
ALBERTVS · DVRER · NVR · FACIEBAT ·
· B · M · F · V · V ·
· M · D · XXIIII ·

45. Frederick the Wise, Elector of Saxony. 1524.
Engraving. 19 × 12.5 cm. London, British Museum.

Prints from wood

Of the vast output of woodcut prints during Dürer's professional life, only the Apocalypse series (52) are now considered to have been entirely worked by him. These designs, incidentally, were not all original; most of them were based on cuts in the first edition of the famous Cologne Bible, published in 1478 when Dürer was a child. But these large blocks, some of the largest he ever visualised, are of particular importance since they offer the closest contact with Dürer's hand, burin and scrive in this medium.

Whilst more than enough windy rhetoric has been churned out by art journalists and even psychologists on the recurrent images and latent symbols in the prints, far less attention has been given the hands responsible for transcribing so much of the complex pen drawn original on to the wood block. Some of the most brilliant results of this exacting and often tedious craft are to be seen in 'The Martyrdom of St John the Baptist (69).

The most outstanding of the craftsmen employed by Dürer over a long period was one, Jerome Andrea. He rendered Dürer's mannerisms of drawing with an immaculate facility, and where one is able to compare the original pen drawing with the cut, the translation has the quality of a facsimile. As an aside perhaps, it is not totally irrelevant to mention Andrea's reference in later life, to 'a pitiless tyranny' endured under the master's insistence on perfection. Little of Andrea's life is reliably documented, but he was exiled from Nuremberg in 1542 for 'mouthing sinful words' to the City Council.

The particular perfection Dürer achieved in his own engraving technique was also demanded of everyone who worked with him. And, in his designs for wood, even more than in his designs for metal, he became increasingly indifferent to the natural limitations of the medium and its tools. Andrea and his colleagues were entirely responsible for the perfect reproduction of the master's line and tonal gradations in the elaborately wrought compositions. Even today, many artists are notoriously indifferent to the methods of reproduction, autographic and mechanical, available to them and are frequently careless of the inherent limitations in a medium.

Dürer constantly and closely supervised the production of the woodcuts, and throughout the great catalogue of prints there are, from time to time, touches of superlative brilliance in handling where his cutting is present. Some of 'The Small Passion' (55–66), and 'The Rhinoceros' (71) are notable for this.

In range of subject matter, it has been said that the scope is less broad than in the metal prints. There is indeed a certain restriction. But this could well be accounted for in terms of popularity of some subjects—commercial success—as well as for personal preference on Dürer's part. What appears of greater concern is that this man, with tremendous physical and mental energy, of great scientific curiosity and with friends among the most intellectual figures in Germany, has left us so little of the things seen around him; of his everyday life and of his prodigiously arduous journeys. He left a far greater written record (often of trivia) than graphic reportage.

Perhaps among Dürer's most perfervid admirers, this reflection is totally unacceptable. At least we may agree that the confidence and swaggering vigour of the cut is sustained in every illustration, however repetitious the thematic material. And, when the variable and often indifferent quality of the woodblock is fully appreciated, these prints may then be properly seen as unique technical masterpieces.

In recent years, several practising engravers of some creative power and repute have been Dürer's harshest critics. They see in Dürer, a man who should have prevented engraving from moving on its downward slope toward mere pictorial representation and perhaps at least delayed the inevitable reproductive doldrums where lesser men assisted in the decay. The charge that Dürer set engraving on that path may not be easily dismissed.

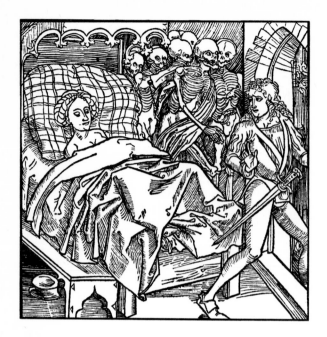 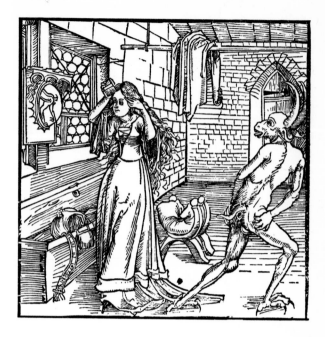

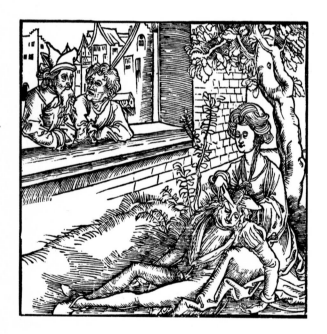 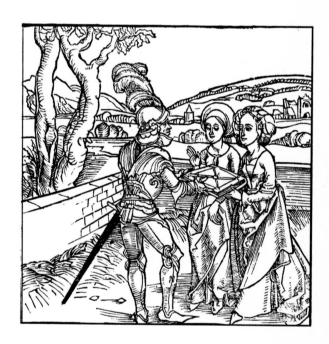

46. Four book illustrations from *Ritter von Turn*. 1493.
Approx. 10.5 × 10.5 cm. Munich, Bayerische Staatsbibliothek.

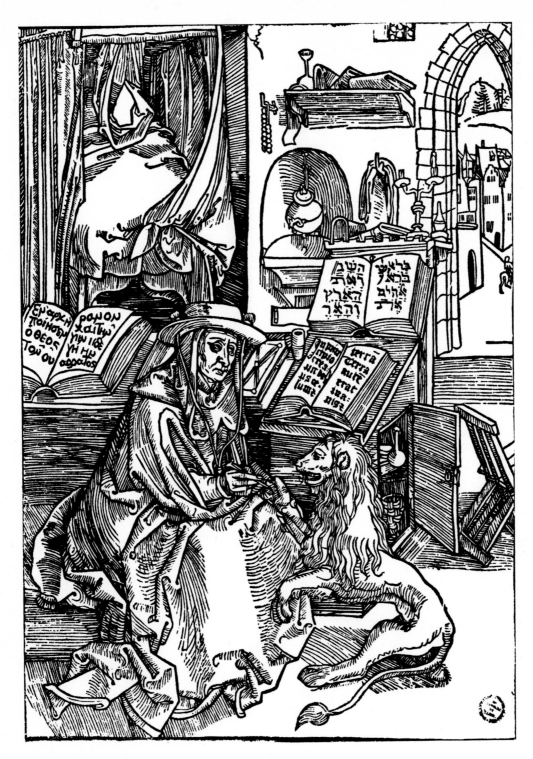

47. St Jerome in the room. *c.* 1492.
 19 × 13.3 cm. Basle, Offentliche Kunstsammlung.

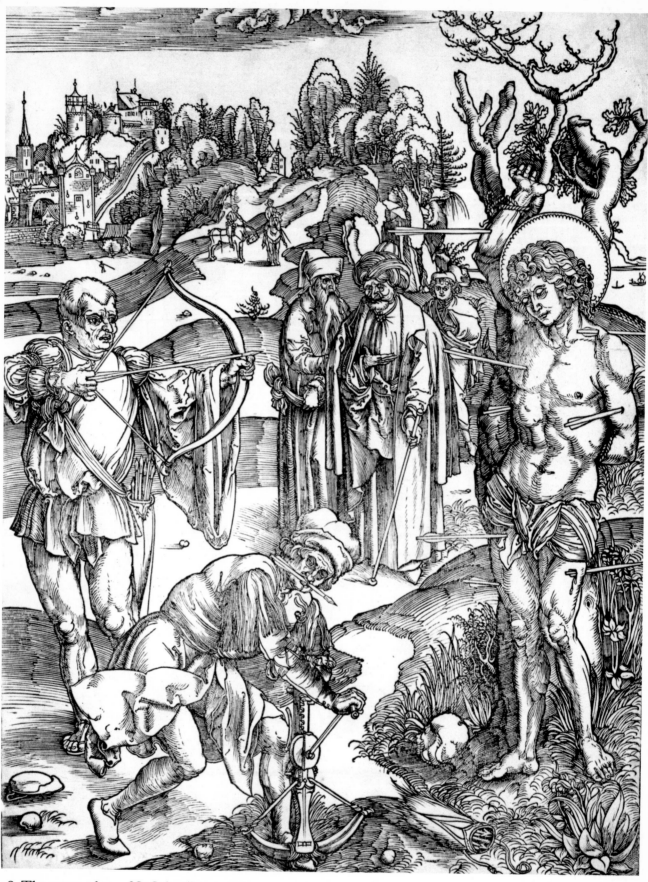

48. The martyrdom of St Sebastian. *c.* 1495.
40 × 29.2 cm. London, British Museum.

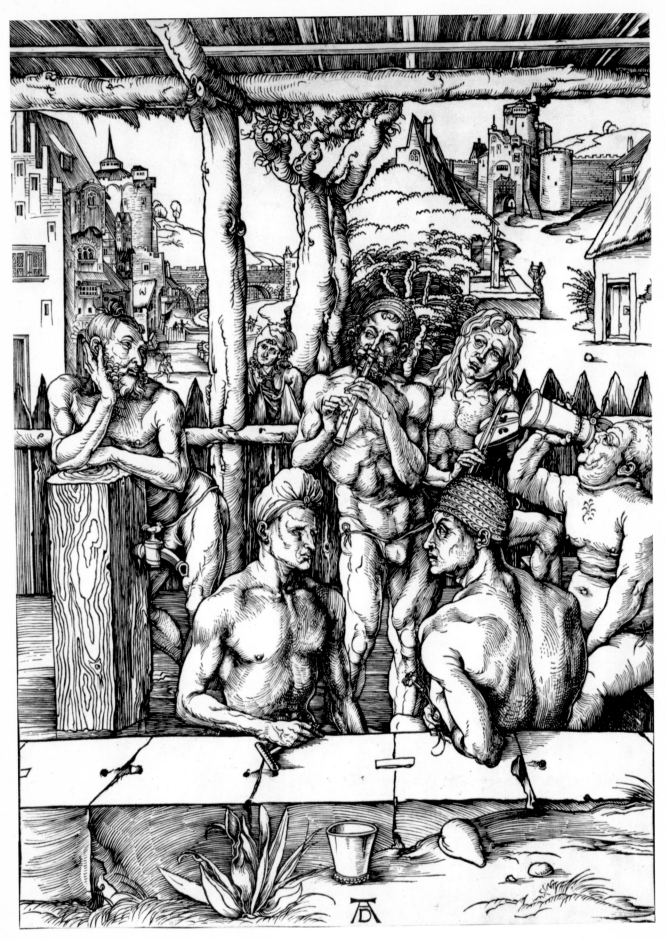

49. The bath house. 1496.
38.7 × 28 cm. London, British Museum.

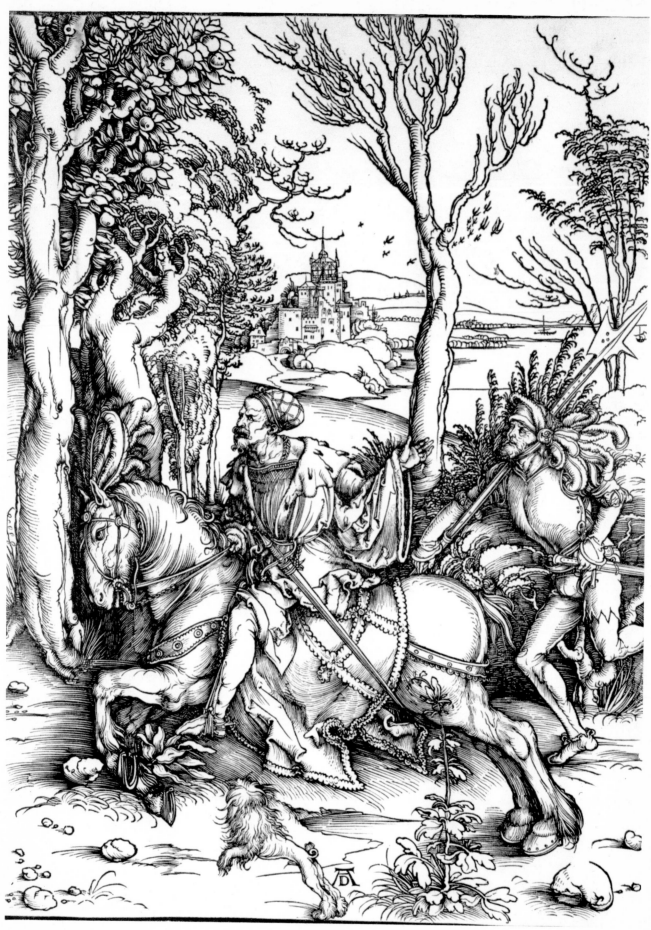

50. Knight on horseback and lansquenet. 1496–7.
39 × 28.2 cm. London, British Museum.

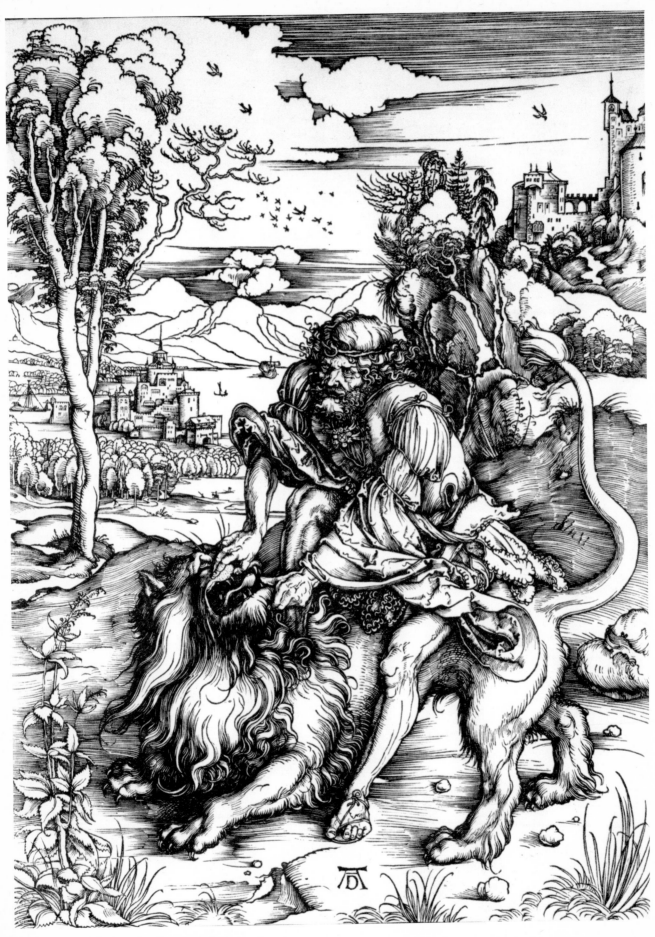

51. Samson fighting the lion. 1496–7.
38.2 × 27.8 cm. London, British Museum.

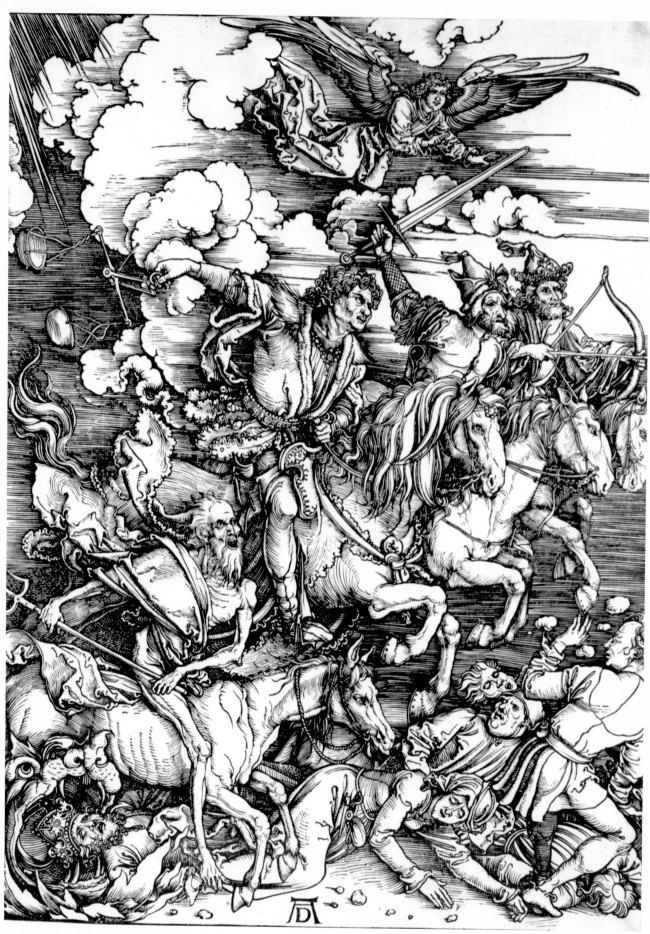

52. The four horsemen. 1497–8.
39.2 × 27.9 cm. London, British Museum.

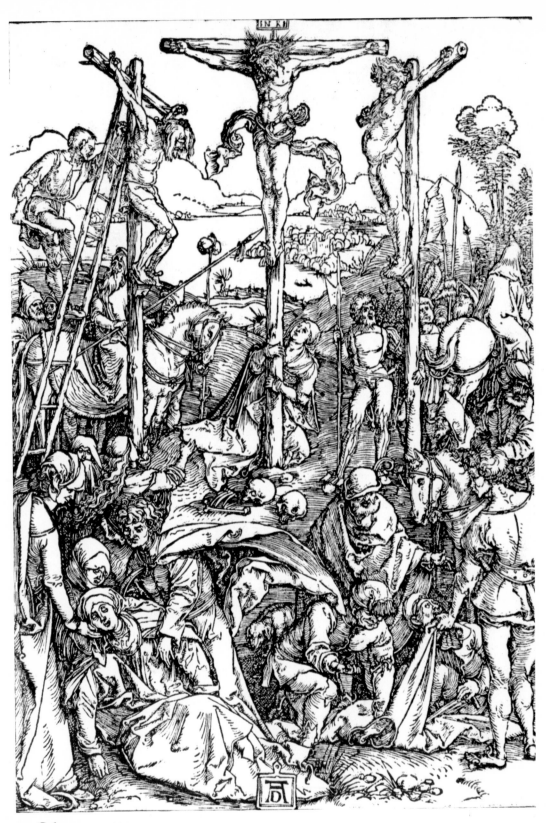

53. Calvary. *c.* 1502.
 1st state. 21.6 × 14.7 cm. London, British Museum.

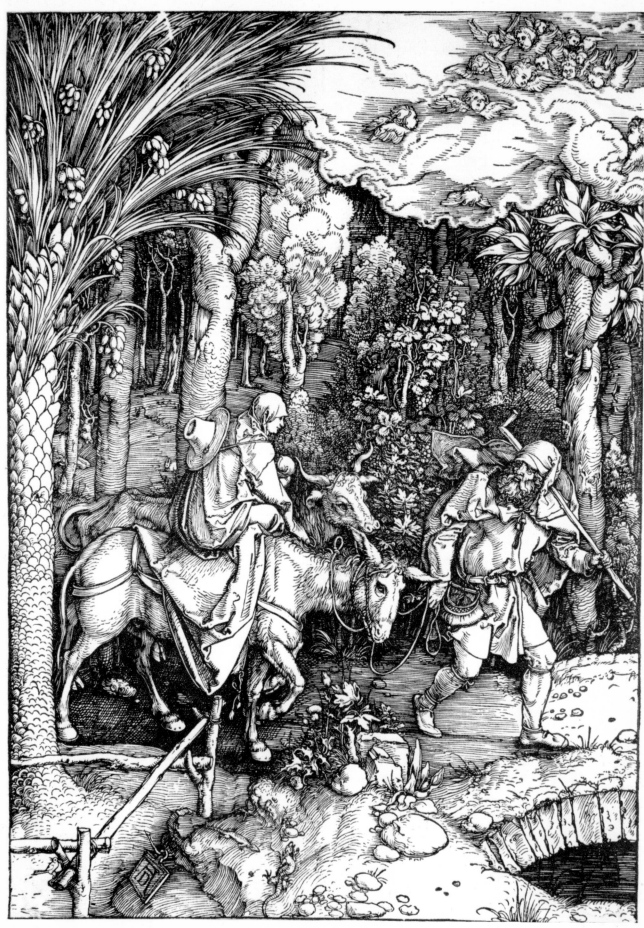

54. The flight into Egypt. 1503–4.
29.5 × 20.9 cm. London, British Museum.

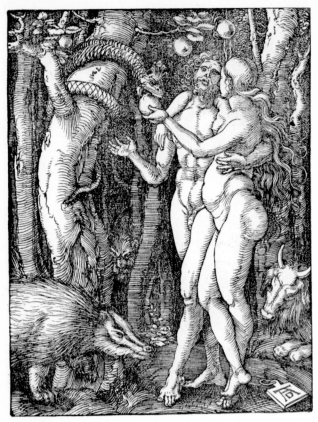

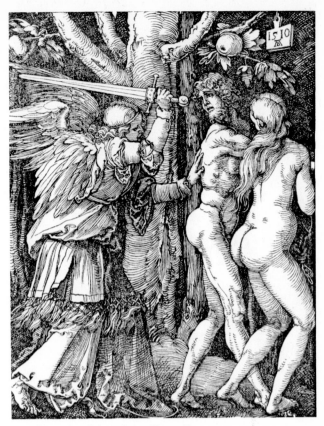

55. The fall of man. 1511.
12.6 × 9.7 cm. London, British Museum.

56. The expulsion from Paradise. 1511.
12.6 × 9.7 cm. London, British Museum.

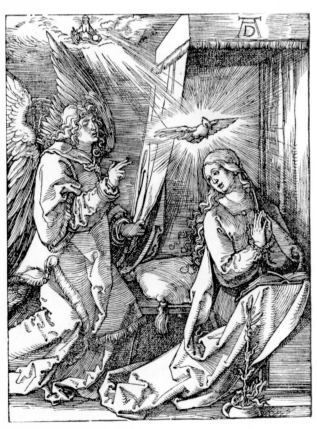

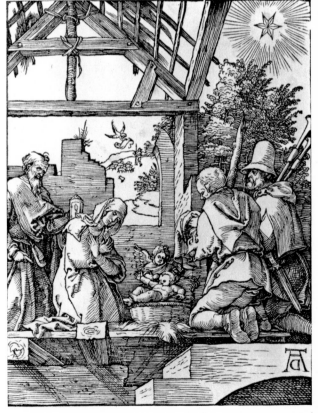

57. The annunciation. 1511.
12.8 × 9.7 cm. London, British Museum.

58. The nativity. 1511.
12.8 × 10.2 cm. London, British Museum.

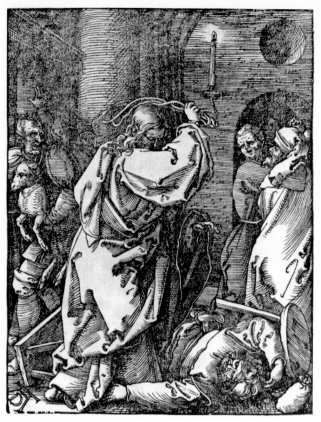

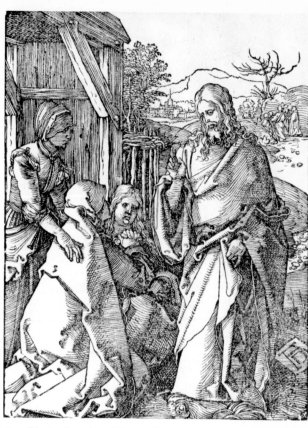

59. Christ expelling the moneylenders. 1511.
12.6 × 9.7 cm. London, British Museum.

60. Christ leaving his mother. 1511.
12.6 × 9.7 cm. London, British Museum.

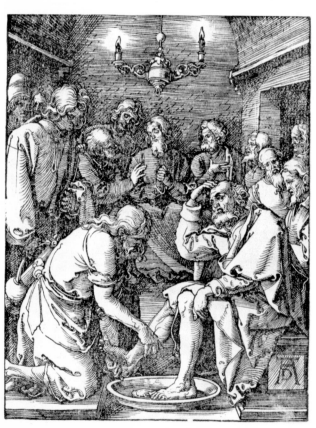

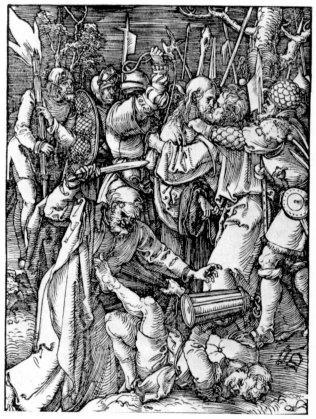

61. Christ washing his disciples' feet. 1511.
12.6 × 9.9 cm. London, British Museum.

62. The betrayal. 1511.
12.7 × 9.7 cm. London, British Museum.

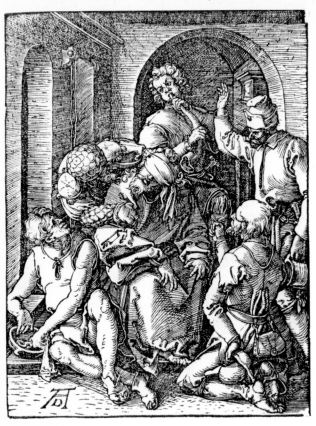

63. The mocking of Christ. 1511.
12.6 × 9.7 cm. London, British Museum.

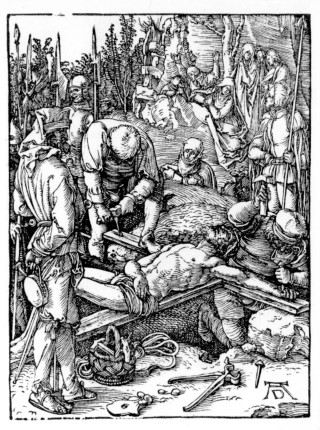

64. Christ nailed to the cross. 1511.
12.6 × 9.9 cm. London, British Museum.

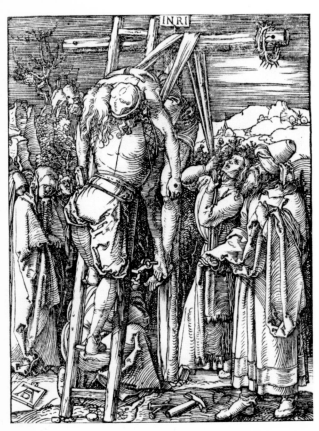

65. The descent from the cross. 1511.
12.6 × 9.7 cm. London, British Museum.

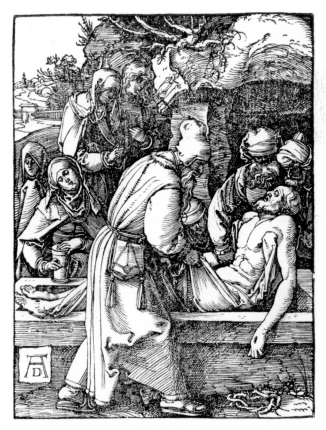

66. The deposition. 1511.
12.6 × 9.7 cm. London, British Museum.

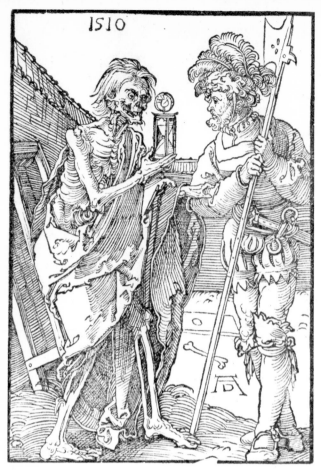

67. Death and the lansquenet. 1510.
 12.2 × 8.3 cm. London, British Museum.

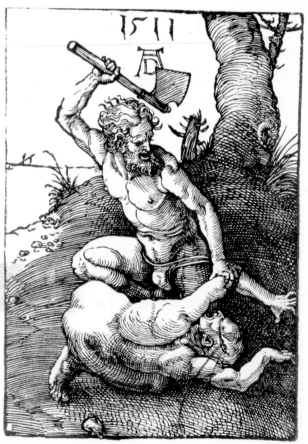

68. Cain killing Abel. 1511.
 11.5 × 8.3 cm. London, British Museum.

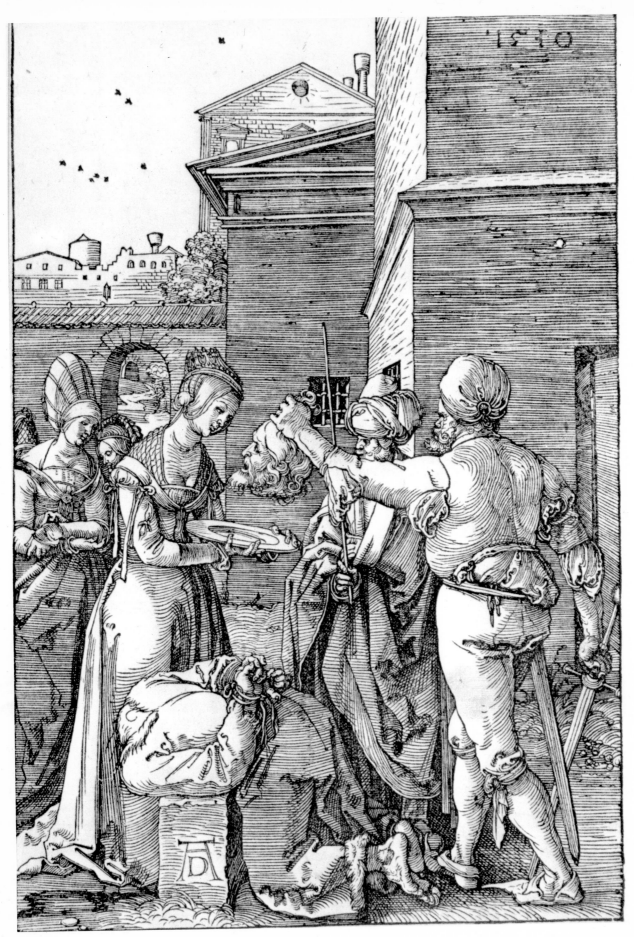

69. The martyrdom of St John the Baptist. *c.* 1510.
39.2 × 27.2 cm. London, British Museum.

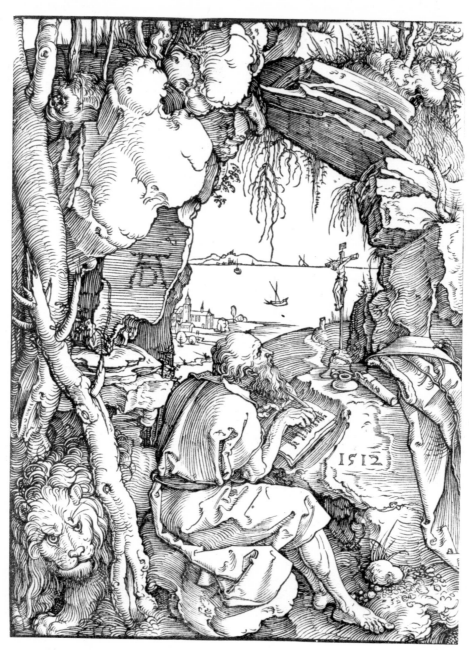

70. St Jerome in a cave. 1512.
 16.9 × 12.4 cm. London, British Museum.

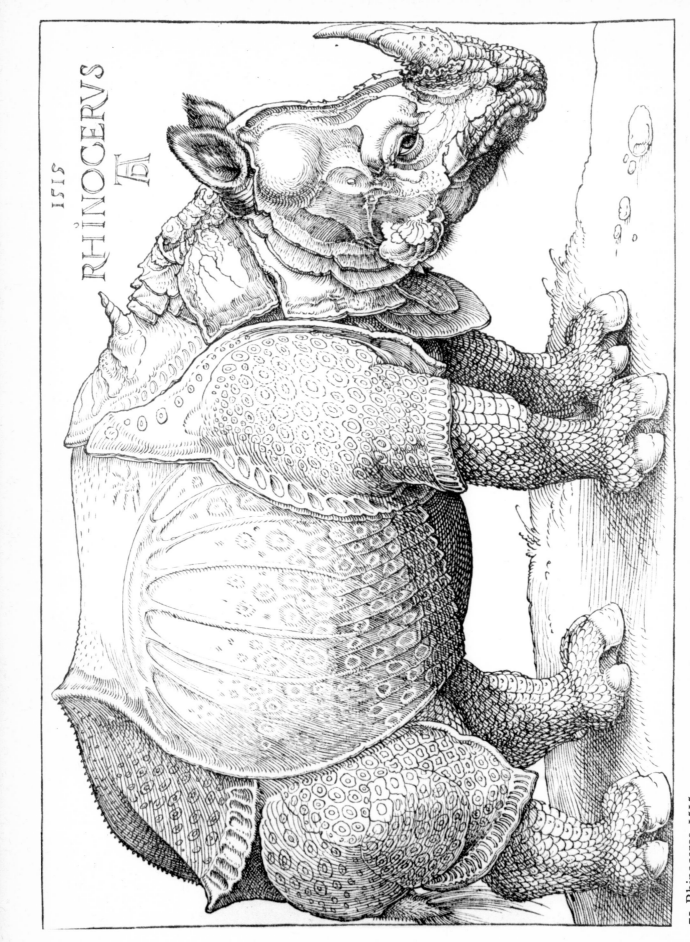

71. Rhinoceros. 1515.
21.4 × 29.8 cm. London, British Museum.

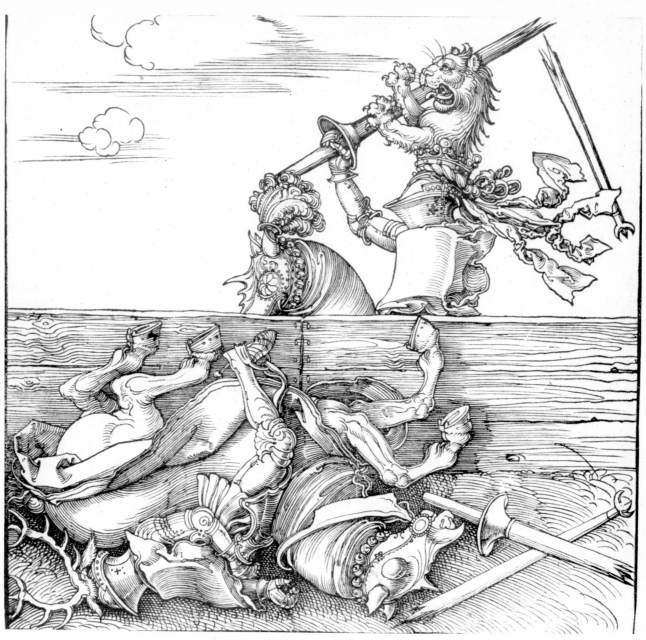

72. The Italian joust. 1516.
 22.3 × 24.2 cm. London, British Museum.

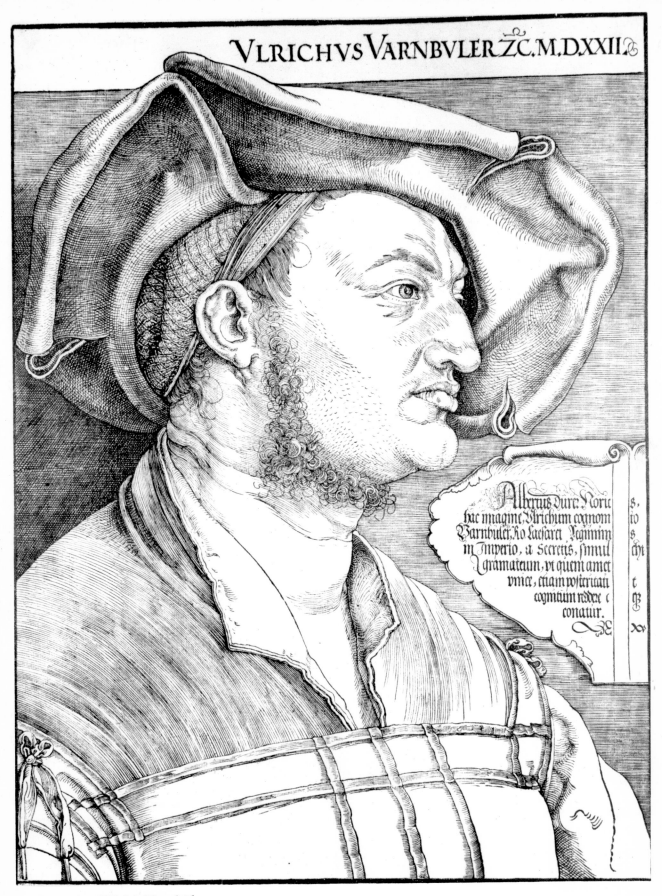

VLRICHVS VARNBVLER ZC. M.D.XXII.

Albertus Durer Norie hac imagine Vlrichum cognom Varnbuler, Ro Caesaret Regimin in Imperio, a Secretis, simul gramateum, vt quem amet vnice, etiam posteritati cognitum redere conatur.

73. Portrait of Ulrich Varnbüler. 1522.
 48.7 × 32.6 cm. London, British Museum.

Acknowledgements

The publishers wish to thank the following for permission to reproduce the works and for supplying material from which the reproductions have been made.

PAINTINGS AND DRAWINGS
Berlin, Kupferstich-Kabinett: 13
Cologne, Wallraf-Richartz Museum: 12
Erlangen, University Library: 1
London, British Museum: 6, 8, 16
London, National Gallery: 7
Madrid, Prado: 9
Milan, Ambrosiana: 3
Paris, Louvre: 4
Rotterdam, Van Beuningen: 5
Vienna, Albertina: 2, 10, 11, 14, 15, 17

PRINTS
All the prints reproduced are from the British Museum, London, with the exception of:
Basle, Offentliche Kunstsammlung: 47
Munich, Bayerische Staatsbibliothek: 46